Alfred Stieglitz: Photographer

Alfred Stieglitz:
Photographer

by DORIS BRY

Museum of Fine Arts, Boston
in association with
Bulfinch Press / Little, Brown and Company
Boston · New York · Toronto · London

This reprint of Alfred Stieglitz: Photographer *and the exhibition,* Alfred Stieglitz and Early Modern Photography,
which it accompanies (Museum of Fine Arts, Boston, September 14 – December 29, 1996)
celebrate the recent acquisition by the Museum of Fine Arts of seven Stieglitz portrait photographs of Georgia O'Keeffe.
These seven images, which had been on loan to the Museum from Georgia O'Keeffe since 1950, were acquired as a
partial purchase/partial gift from The Georgia O'Keeffe Foundation.
This acquisition was made possible by the enthusiastic support of Malcolm Rogers, Ann and Graham Gund Director,
and Brent Benjamin, Deputy Director for Curatorial Affairs.
The exhibition Alfred Stieglitz and Early Modern Photography *was organized by Clifford S. Ackley, Ruth and Carl Shapiro*
Curator, and Anne E. Havinga, Assistant Curator, of the Department of Prints, Drawings, and Photographs.

For literature on Stieglitz since 1965 see the bibliography in
Richard Whelan, Alfred Stieglitz: A Biography, *Boston: Little, Brown and Company, 1995.*

Fourth printing, revised, 1996

Library of Congress Catalogue Card Number 65–24359

ISBN *0-8212-2352-6*

Printed by The Stinehour Press, Lunenburg, Vermont

Bound by Acme Bookbinding Co., Charlestown, Massachusetts

Designed by Carl F. Zahn

Bulfinch Press is an imprint and trademark of Little, Brown and Company (Inc.)

Published simultaneously in Canada by Little, Brown & Company (Canada) Limited

Foreword

THE STIEGLITZ COLLECTION in the Museum of Fine Arts has the distinction of being the first group of photographs by one artist to enter an American museum. Like so many of the Boston collections, it is also first in quality. Therefore, with great pride we publish, for the first time, a fully illustrated catalogue of our Stieglitz Collection of prints. To do justice to this master of the camera, no pains have been spared to produce a publication of unmistakable quality.

The original gift of twenty-seven photographs was given to the Museum in 1924 through the interest of Dr. Ananda Coomaraswamy, for many years Keeper of Indian and Muhammaden Art at the Museum. He and Alfred Stieglitz became great friends. He early recognized the genius of Stieglitz and, thanks to his belief and his influence, the first prints were presented to the Museum.

This book honors that fruitful partnership. It could not be recalled in a better way than to quote from the Museum *Bulletin* of April, 1924, the perceptive words of Dr. Coomaraswamy on the newly acquired collection: *"Mr. Stieglitz makes few prints from his negatives. It is an error to suppose that an indefinite number of equally perfect prints can be made from any one negative. It is true that the negative does not appreciably deteriorate; but so much vitality, such closely coordinated reaction is necessary for the production of wished-for results in printing, that human energy does not permit of many repetitions of the process.*

"Mr. Stieglitz' work well illustrates the fundamental problems of the photographer. The camera is a means of expression with virtues and limitations of its own; the photograph which looks like a drawing, etching or painting, is not a real photograph. The peculiar virtue of photography, and at the same time, in the hands of a purely mechanical operator, its severest limitation, is its power of revealing all textures and revealing all details. The art of photography is to be sought precisely at this point: it lies in using this technical perfection in such a way that every element shall hold its place and every detail contribute to the expression of the theme. Just as in other arts there is no room here for the non-essential. Inasmuch as the lens does not in the same way as the pencil lend itself to the elimination of elements, the problem is so to render every element that it becomes essential; and, inasmuch as in the last analysis there are no distinctions in Nature of significant and insignificant, the pursuit of this ideal is theoretically justified. A search for and approach to this end distinguishes the work of Alfred Stieglitz. It must not be supposed that the adoption of a particular equipment (such as lenses of critical focus or particular color screens) can by itself achieve the desired result; here, as elsewhere, it is the man behind the tool, and not the tool, that counts."

The initial gift of photographs from Alfred Stieglitz in 1924 was augmented by a gift of forty-two prints from Georgia O'Keeffe in 1950. We are exceedingly grateful to her for this generous benefaction.

In printing our catalogue we are most grateful to Mr. John Walker, Director of the National Gallery of Art, for permission to reprint the text Doris Bry wrote in 1958 for the catalogue of the National Gallery's first exhibition from its Stieglitz holdings.

Prior to the distribution of the Stieglitz prints, Miss Bry had worked with Miss O'Keeffe on a definitive catalogue of the entire oeuvre of Alfred Stieglitz, an experience which more than qualified her to discuss his unique contribution to the art of photography. We appreciate her permission to reprint the essay from the National Gallery catalogue, with her substantial alterations.

Boston, 1965 PERRY T. RATHBONE, *Director*

The Alfred Stieglitz Collection in the Museum of Fine Arts

SOME day when the story of photography as an art is finally told, the Museum of Fine Arts' acquisition of Alfred Stieglitz's photographs will represent a landmark in that history. The two men most responsible, Dr. Ananda Coomaraswamy and Alfred Stieglitz himself, seem at first glance an unlikely pair to have accomplished such a feat.

Dr. Coomaraswamy, Keeper of Indian and Muhammaden Art at the Museum from 1917 to 1947, was an Indian scholar, steeped in the cultures and philosophies of the past. Gentle, elegant, and thoughtful, his interests ranged over the entire pre-modern worlds of Europe and Asia. He wrote of them with erudition, charm, and profound insight. He was also an enthusiastic amateur photographer and often joked about his inability to resist buying any new photographic gadget on the market.

Alfred Stieglitz, born an American but strongly affected by his European ancestry and education, was a slight, wiry man of intense passion, incredible energies, and ardent convictions, which he dedicated not only to his own photography but also to the many photographers and painters he championed. In a world which had insisted that photography—the product of a machine—could never be an art, he demanded, and ultimately won, its recognition.

The events by which the Museum now has a group of sixty-nine Stieglitz prints can be told very simply. Early in 1923, Dr. Coomaraswamy, on one of his frequent visits to Stieglitz in New York, asked for some of his photographs for the Museum. Stieglitz was pleased and astonished, for the Museum at that time was not only known as one of the most conservative art museums in America but was also revered as an institution of the highest standards.

During the months that followed, prolific ones for Stieglitz, the selection of the Boston group was a constant problem. While Coomaraswamy worked within the Museum for the acceptance of the prints and their acquisition on the terms Stieglitz had set, Stieglitz worked to assemble the finest prints of his career. Often dissatisfied with a print he wanted to include, he worked to surpass the prints he had already made from certain negatives.

To a close friend and associate, Herbert J. Seligmann, he wrote late in November of one (Plate 38), "*I have just hung up 19 prints of one subject—the first of the Cloud Series of last year . . . All day yesterday & all day today I have been battling with that negative & with icy water & ever changing light—A terrible ordeal really—Now I hope I have at least 2 or 3 fine prints—one intended for the Boston Museum. . . .*"

Not until early in 1924 had Stieglitz made a choice which satisfied him, and by then the group consisted of twenty-seven prints, rather than the dozen first intended. Each was mounted, matted, and framed by Stieglitz. Several of those he gave to Boston were finer than those he kept for himself; this was the first time he had ever parted with his best print for anyone.

When he died in 1946, Stieglitz left the task of disposing of his prints to Georgia O'Keeffe. The full details of how these prints were divided are beyond the scope of this essay. Briefly, however, it can be said that first a key set was made, consisting of more than 1,500 prints and showing every possible aspect of Stieglitz's photography.[1] The remaining prints were then arranged in smaller groups for public institutions.

By 1950, Miss O'Keeffe had selected a group of forty-two prints for the Museum of Fine Arts. They were chosen to supplement and to extend Stieglitz's original gift, with the special significance of that gift in mind. For the most part prints were added which did not exist in 1924: late prints from very early negatives, as well as pho-

1. The key set consists of virtually the best single original mounted print from every negative made by Stieglitz and still in his possession at the time of his death.

tographs made after 1924. Thus the entire chronological range of his work was, for the first time, fully represented in the Museum.

Although many institutions received larger numbers of photographs which emphasized one aspect or another of Stieglitz's work, the Boston group was deliberately kept as small and as perfect as possible. Each print selected by O'Keeffe was intended to match the caliber of those Stieglitz himself had chosen, so that the group as it now stands may be considered the finest, most highly distilled small collection that can ever be assembled to show the full extent of his work in concentrated form.

Just as the Museum of Fine Arts was the first to recognize the Stieglitz photographs as art in 1924, it now becomes the first institution to publish a fully illustrated catalogue of its holdings, illuminating their significance more fully than can any written words. I am grateful to the Museum for giving me the opportunity to record some of the facts about these photographs by Alfred Stieglitz.

D. B.

Alfred Stieglitz: Photographer

WHEN Dr. Ananda Coomaraswamy asked Alfred Stieglitz in 1923 if he would give the Museum of Fine Arts some photographs for its Print Department, a major battle was won in Stieglitz's lifelong war for the recognition of photography as an art. Although Stieglitz was then fifty-nine, a world-famous photographer since his twenties, no major American art museum yet included photographs in its collections or considered them equal to prints and drawings.

Early in 1924 Stieglitz finally sent the Museum a group of twenty-seven photographs. They were first exhibited there with works of Goya and Dürer. In 1928 the Metropolitan Museum of Art requested and received Stieglitz prints. After Stieglitz's death in 1946, the National Gallery of Art asked for the key set of his photographs, a fitting culmination to his life's work. In each case Stieglitz was the first photographer whose prints American museums wished to house with other notable achievements in the graphic arts. He stands in the United States as the rock on which photography as an art was built, a great fighter for it, much loved and much hated.

This catalogue attempts to tell some facts about Stieglitz, the photographer, and to suggest briefly his impact on photographic history, both as creative artist and as an active personal force. His own photographs, his furthering of other photographers, and his general activities for the acceptance of photography must all be considered. His place in the history of modern painting in the United States is well known and is arbitrarily excluded.

I. The Early Period (1883–1901)

STIEGLITZ started photographing in 1883 at the age of nineteen, during his first year at the Berlin Polytechnic, when photography was also young. He had enrolled in 1882 to study mechanical engineering. A scant four months later he spotted a small camera in a shop window, of which he later wrote, "... *I bought it and carried it to my room and began to fool around with it. It fascinated me, first as a passion, then as an obsession. The camera was waiting for me by predestination and I took to it as a musician takes to a piano or a painter to canvas. I found I was master of the elements, that I could work miracles; that I could do things which had never been done before. I was the first amateur photographer in Germany, or, for that matter, anywhere. But I had much to learn.*"

After making a few photographs of his room, the views from his window, and some self-portraits, he enrolled in a photochemistry course and, soon afterwards, under the stimulus of Professor H. W. Vogel,[2] turned entirely to the study of photochemistry, later continuing his scientific studies at the University of Berlin until 1890.

At first Stieglitz seemed the slowest student in his class. Struggling with the assignment of photographing a white plaster Juno draped with a black velvet cloth, he persisted in making one negative after another, long after his fellow-students had given up. Finally the professor told him that no one could photograph accurately the range of values from white plaster to black velvet, and that photography had to compromise.

But compromise was not in Stieglitz's nature. Told that the camera and its materials had inherent limits, he defied them. Typical of his reactions to such statements was the experiment he set up when told that the camera could only be used with daylight. He shut up his camera in a cellar illuminated only by a weak electric light bulb,

2. Dr. Hermann Wilhelm Vogel (1834–1898), German scientist responsible for the invention of orthochromatic (noncolor-blind) plates and also an early exponent of photography as an art.

focused on a dynamo, and made a 24-hour exposure. The resulting negative was a perfect one, effectively refuting the necessity of daylight for photography.

He later described his earliest student equipment as consisting of a large view camera with no shutter, a tripod, and a package of 18 × 24 cm. glass plates. Two dozen of these plates were all that could be carried comfortably. With this thirty-pound load he risked few exposures until certain of what he was doing, often returning from a trip having taken no pictures. Present-day lightweight cameras, designed to make many exposures easily and fast, did not then exist. Yet the fact that Stieglitz began his photographic studies when he did gave him the advantages of better printing papers, dry plates,[3] and freedom from the burden of portable darkrooms necessary for the wet plates of the 1870's. The passionate enthusiasm of this young student was well matched to the technical advances of this decade (1880–90), perhaps unequalled in any other comparable span of photographic history until the 1960's.

These innovations stimulated the public's participation in photography, which also reached its first peak in the 1880's. Photography as we know it was a scant fifty years of age[4] and had been generally considered a scientific curiosity, not an art. But widespread interest in the new medium now aroused a ceaseless controversy about whether or not photography was an art—a battle which Stieglitz led throughout his life.

Many of Stieglitz's friends among the painters kept telling him that the product of a machine could never be an art. He noticed, however, that although many of them said they wished they had painted what he had photographed, he never wished he had photographed what they had painted. While still a student in Berlin, Stieglitz, an artist who knew intuitively that photography was his medium, decided to fight for its recognition as a creative art equal to painting. The best way to gain acceptance, he innocently believed, was to become a photographic authority, and to become an authority he had only to win all possible awards and medals. He won his first prize in 1887, photographed and experimented constantly, and soon had won more than 150 medals in important exhibitions all over the world.

STIEGLITZ's photographs may be considered as falling into three main periods: the early period (1883–1901), which consists mainly of prints made in Europe and in New York City; the Photo-Secession era (1902–1917), which includes principally photographs made in New York; and the later years (1917–1937), when his photographing was done almost entirely in New York City and at Lake George.

The surviving prints of the Polytechnic years (1882–1886), although of relatively little interest as works of art, remain a fascinating demonstration of the learning process of this unorthodox student. They illustrate his early efforts to expand the uses of the camera and its materials, and his ways of finding his own answers to photographic questions. It is important to realize how thoroughly Stieglitz absorbed the chemistry and physics underlying the photographic process during his academic years in Germany, and how this understanding became a tool for the rest of his life.

His earliest public recognition came from England and Germany, the countries which housed the most articulate supporters of photography as the youngest of the arts. It began in 1887 when Stieglitz won the first of his first

3. Although dry plates existed in 1883, Stieglitz was taught the traditional wet plate collodion methods of photography during his first year of academic study.

4. 1826 is taken as the date of the world's first photograph, based on Gernsheim's *The History of Photography*.

prizes for a print[5] he had sent to the *Amateur Photographer* (London) Holiday Work Competition. The judge who made the award was Dr. P. H. Emerson, then the most prominent English advocate of photography as an art. Dr. Emerson later wrote Stieglitz about his entry: *"It is perhaps late for me to express my admiration of the work you sent in to the 'Holiday Competition.' It was the only* spontaneous *work in the whole exhibition and I was delighted with much of it."*[6]

This perceptive comment foreshadowed what was to become the touchstone for Stieglitz in his critical evaluation of his own prints: the presence of freshness and life, added to artistic excellence, which he regarded as more essential than a dead technical "perfection."

The prints Stieglitz made in 1887, particularly those made during a trip to Italy, can be considered the first cohesive body of work he produced comparable in quality to his later work. They reached and maintained a consistently high level which was widely acclaimed. It is significant that in later life, having lost or destroyed most of his earliest work, Stieglitz had kept prints from these negatives and showed them to represent the earliest stages of his photographic evolution. The 1887 prints remain primarily, however, the work of a gifted young man, savoring the country village life he saw during vacation walking trips: pretty young girls, amusing little boys, picturesque old men and women, striking landscapes. Their composition is strong and simple, but they tend to lack the subtle structure of his later work. At their best they go far beyond the artistic clichés of the period and remain outstanding today. In summary, most of the 1887 work describes the external aspects of the world about him, to which was added his youthful ambition to make only "perfect" negatives.

The emotional as well as the geographic division between his life in the United States and that in Europe was an important influence on Stieglitz and can be most clearly seen by comparing three outstanding groups of his early prints: those he made in Europe in 1887 and 1894 and those of the 1890's, photographed in New York.

Although born in New Jersey, Stieglitz attended schools in New York until 1881, when he went to Germany to continue his education. He later spoke of his student days in Berlin as his happiest years, for in Europe he experienced sympathy for and understanding of his work in photography and his aims as an artist. There he lived and worked among those who acknowledged aesthetic values independent of money—who respected and admired the values inherent in fine craftsmanship. This world was congenial to him in a way that made his return to New York in 1890 a rude shock.

Accustomed to photography's high though controversial status in Europe, he was shocked by the provincialism of his own country, where photography was considered a hobby on a level with a fad for bicycling. No one had any interest in photography as an art, and American photographic work was virtually unknown to his European colleagues. Stieglitz found a public enraptured by the appeal of "You press the button, we do the rest," the Eastman

5. "A Good Joke," (No. 60A). All print identification numbers in this text refer to those in the definitive catalogue of Stieglitz prints (work in progress—D.B.) and have been used to catalogue and identify all prints in the key set and other public collections.

It is interesting that the print Stieglitz kept from this negative (now in the key set) is not the actual print which won the prize but is a later print made in the 1890's. The matting and cropping of the later print, resulting in a much stronger composition than the 1887 presentation, suggest the more discriminating use of space Stieglitz had learned in the few intervening years. This print is reproduced in his original presentation in the *Amateur Photographer* (London), July 11, 1888.

6. The original of this letter, as well as the other source material used in this text, is now housed in the Alfred Stieglitz Archive, Collection of American Literature of the Yale University Library, by gift of Georgia O'Keeffe in 1949.

company slogan which accompanied the first Kodak camera craze in 1888. As Stieglitz later wrote of these years: *"Every Tom, Dick, and Harry could, without trouble, learn to get something or other on a sensitive plate, and this is what the public wanted—no work and lots of fun."* Nothing could have been farther from his dream for photography.

New York itself must have seemed an extraordinary contrast to the older civilization of Berlin, where Stieglitz had spent the preceding eight formative years. He was at first lonely and miserable, although the city fascinated him. Later he came to love it; it became home to him. Always he was keenly interested in what he saw. In the past it had been Europe, now it was New York.

Inevitably he responded in photographic form to the impact of a new world, and the photographs he made in New York in the 1890's constantly broke new ground. Turning away from the rather romantic and picturesque themes he had favored earlier in Europe, he began to photograph the unfashionable, but to him exciting, activity of the teeming city streets.

Equally revolutionary was his use of a small,[7] hand-held camera,[8] of which he remarked: *"Originally known under the odious name of 'Detective,' necessarily insinuating the owner to be somewhat of a sneak, the hand camera was in very bad repute with all the champions of the tripod,"* and was looked on as *"a mere toy."*

By freeing the photographer from the cumbersome view camera, tripod, and black cloth then customary for serious work, the hand camera caused a revolution perhaps only comparable to that made in the 1920's by the invention of the Leica camera. Stieglitz was able to photograph an immediate event with a quickness which had been mechanically impossible before (Plate 2, "The Terminal," No. 128B).

The work Stieglitz produced in New York in the 1890's with his hand camera is of special interest, both in itself and for understanding the evolution of his later photographs and their underlying concepts. Most of these negatives he printed at that time as enlargements (photogravures or gum and carbon prints) and as glass slides, in marked contrast to his later conviction that photography in its truest sense demanded the contact print.[9] It is doubtful whether he printed more than ten out of a body of several hundred small negatives as contact prints in this early period. In the years that followed he assumed these negatives were lost, until he came across some of them unexpectedly in 1917. Stieglitz, the mature artist, then looked at the work of Stieglitz, the young artist, and saw new possibilities in the old negatives. At intervals during the 1920's and thereafter he made contact prints

7. With few exceptions Stieglitz's prints were made from 4 x 5 inch and 8 x 10 inch negatives. The words "small" and "large" as used in this text refer to contact prints from these two negative sizes, respectively. ("Large" also includes the 18 x 24 cm. early European photographs.)

8. Although the hand camera had been in existence in many forms in the 1880's, it had seldom been used for serious photographic work.

9. The photographic negative is the first visible state in which a photograph exists. Every process used thereafter for making a positive print has inherent in it a potential loss of tonal values, since it is one or more steps away from the original conditions under which the photograph was taken. Within limits, technical manipulations in printing can enhance values imperfectly present in the negatives, or can minimize those present which are not wanted.

A contact print is made by the exposure to light of sensitized photographic paper in *direct* contact with the negative and is the same size as the negative. In its nature it is the printing process that most closely renders the values in the negative and permits a minimum of technical manipulation.

An enlargement is a print made by exposure of the sensitized paper to light through an enlarger lens at some distance from the negative. The large variety of these techniques and available papers has always implied greater use of technical manipulations in printing enlargements than in contact printing.

The problems of *exact* reproduction in a print of the tonal scale in the photographic negative remain unsolved.

from them on ordinary chloride papers,[10] and his early work became best known to a new generation from exhibitions of these prints. They express with delicacy and strength his sense of the life of the growing city at the turn of the century.

Stieglitz spent the summer of 1894 photographing abroad, and the resulting prints can be considered the third outstanding group of his early period, reflecting what he had learned in New York since 1890. They represent his finest European work, with an integration of intention and achievement, a certainty of line, form, and print caliber that give them, taken as a whole, the timeless quality characteristic of his best work. In general they are devoid of the sentimentality often seen in his more youthful work of 1887 (e.g., "The Wanderer's Return," No. 60B), when he was more directly influenced by the prevailing romantic spirit of the era—a climate of feeling in which Rubens' portrait of Helena Fourment was his favorite painting.

Stieglitz was a dramatic innovator in his early period, always attempting the impossible, and he was so much ahead of his time that photographers often doubted that such things could be done. This was true throughout his life. In 1887 he became the first amateur to use the new orthochromatic plates exclusively. In 1889 he was winning prizes with prints on the new Pizzitype paper (printing-out platinum paper) not yet in general use. That same year, after exposing, developing, and printing a photograph of the Berlin Jubilee Exhibition in the unheard-of speed of 37 minutes, he was told that it was a useless stunt. Stieglitz replied that he had demonstrated that photography might some day be of value to record the news.

Most often turning to his hand camera to extend the frontiers of photography, during the 1890's he captured on film the first photographs made in snow, in rain, and at night. In 1893 came the first successful photographs made during a blizzard, something which had previously been considered impossible. Characteristically, Stieglitz made his point not with one print, which might be called accidental, but with several dozen made during that snowy New York winter.

The summer of 1894 saw the first successful "rainy day" photographs (Plate 5, "A Wet Day on the Boulevard [Paris]," No. 109A), and 1896 marks the first night photographs, with and without "animated life."[11] (Plate 6, "Reflections—Night [New York]," No. 128D). All of these can be considered an extension of what he had learned photographing the dynamo in the cellar: that a photograph could be made wherever there was light.

Stieglitz's early period as a photographer was marked by new work and innumerable honors and prizes. Seen together, the prints now remaining from these years sum up a time of learning, experimentation, and artistic growth, from which Stieglitz emerged as one of the world's foremost photographers with a clear, firm knowledge of the directions he believed essential for the recognition of photography as an art.

Throughout his life, his own photography paralleled his work as a public champion of the medium. His impact as a personal force on photographic history is almost beyond description. Photography, as well as life, was always a war for Stieglitz, and in it he was not only a fighter but one who had to—and did—win. As Arthur Dove once wrote him: *"You follow through anything you do with your whole life. . . . Am convinced that you have a will through living your life as an idea that makes things happen. . . ."*

10. Platinum paper could no longer be bought in the 1920's.

11. Others were also working at night photography in this year. *Cf.* Stieglitz, "Night Photography with the Introduction of Life," *American Annual of Photography and Photographic Times Almanac for 1898*, New York, 1897.

Like many strong individuals in the arts, Stieglitz paradoxically came to believe that the work of a group would be more effective than that of a single person and had the ideal of working for photography through a band of talented photographers who shared his convictions. His battle was always fought on many photographic fronts: organizations he joined, formed, directed, or left; publications he edited, published, and to which he contributed; exhibitions he organized and sent all over the world to demonstrate photography as an art; his own photographs, and those of fellow workers he believed in; conversations; letters; and, from 1905 on, exhibitions in his galleries. All were part of his fight. His energies were prodigious, and their use for photography can only be very briefly suggested in these pages.

Probably the first organization he joined, while still in Berlin, was the German Society of the Friends of Photography. This seems to have been a group largely devoted to dinners, discussions, and competitive exhibitions of members' work. After his return to the United States in 1890, Stieglitz joined the languishing Society of Amateur Photographers of New York, which he found debating whether it might find rejuvenation as a bicycle club. Stieglitz plunged into all its photographic activities and later was one of those responsible for its merger with the New York Camera Club in the spring of 1896 to form a single major American photographic group, the Camera Club of New York.[12]

Meanwhile, Stieglitz had begun his editorial activities in photography and from 1893 to 1896 (when he resigned) was editor of the *American Amateur Photographer*, where he imposed his rigorous standards. Contributors who failed to meet them could expect rejection with the frequent terse comment from the editor, "technically good, pictorially rotten." In 1897 Stieglitz founded and edited *Camera Notes* for the newly formed Camera Club of New York, and he soon made it famous throughout the photographic world because of the fine selection and excellence of its illustrations. In spite of disagreements within the club, Stieglitz continued to run it through volume 6, no. 1. In 1902, when accused of "rule or ruin" tactics he resigned. After only three numbers without his direction, the publication had so deteriorated that it came to an end, although when Stieglitz was editor its subscribers had ranged from Boston to Calcutta.

II. The Photo-Secession Period (1902–1917)

By 1902 Stieglitz, now thirty-eight, had long since become the authority in his chosen field. He found, however, that his own achievements were not enough to win recognition for photography. Although he had always battled for the work of serious colleagues, as well as his own, it had been through established groups with large dissident factions. Finally, in 1902 he founded an entirely new group of his own, the Photo-Secession.[13] Its primary aim was the advancement of pictorial photography. As its leader he gathered around him a group of talented American photographers dedicated to this same aim. Those whose work alone might have entitled them to admission were rejected by Stieglitz because of *"their avowed or notoriously active opposition or equally harmful apathy."*

As a condition for its participation in outside exhibitions, the Photo-Secession insisted that its collections be

12. The anticlimactic ending of Stieglitz's active membership occurred when the Camera Club voted to expel him in 1908, a fact that was recorded on the front page of the *New York Times*. The resulting furor brought about his reinstatement shortly thereafter.

13. Frank Eugene, Gertrude Käsebier, Joseph T. Keiley, Edward Steichen, Clarence H. White, and others are listed with Stieglitz as its founders.

accepted, hung, and catalogued as an independent unit. In spite of the outcry against Stieglitz for being a dictator, the brilliance of the group's work usually won acceptance of its conditions and quickly brought international acclaim to American photography. Organizers of photographic exhibitions here and abroad wrote to Stieglitz when they wanted work from the United States, and he now sent them prints by the Photo-Secession. Shortly after its first year, Stieglitz had received 147 requests for exhibitions of the organization's work.

The group's unprecedented policies, however, made Stieglitz the center of the storms which arose as he and his associates put his ideas into practice. In an article published in 1903, he described in detail their objectives, so that *"the photographic world may be disabused of its notion that there is something mysterious and secret about the Photo-Secession."* Stieglitz went on to declare that the movement insisted upon *"the right of its members to follow their own salvation as they see it, together with the hope that by force of their example others, too, may . . . see the truth as they see it. . . .*

"The sham of so-called high standards and the exploitation of the names of painters, known and unknown, who have been induced to pat Photography patronizingly upon the head, the ministration to the vanity of individuals, the substitution of injudicious praise for honest criticism, the complacent acceptance of the mediocre as perfection, all have injured Photography and forced the issue."

The critics and the public of these years were often as involved as the photographers in the new directions Stieglitz was showing them and took sides enthusiastically for and against his exhibitions and ideas. In characteristic vein, a writer for the art section of the *New York Times*, after stating his own belief, then prevalent in art circles, that photography is a *"machine-made handicraft into which art does not enter,"* was nevertheless obviously beguiled by the Photo-Secession, of which he gives us this contemporary report: *". . . They refuse to exhibit their prints any longer beside the work of the photo-Philistines, and they have gravitated into a loose organization with its centre in New York, called the 'Photo-Secession.' Their prints are as costly as water-colors of equal size; they pass weeks elaborating one perfect negative; they pretend that to them also is due the title of artists, since their management of the camera and the plate is equivalent to the management of brush and colors by the painter. In a word, say their detractors, they are stark staring mad! It is the exhibition of these combative, self-assertive, and, it must be confessed, interesting secessionists from photo-Philistia, which will open at the Arts Club next Wednesday. . . ."*

The exhibition referred to above, held in 1902 at the National Arts Club, New York, was the first of the many Photo-Secession shows through which Stieglitz set out to demonstrate photography as an art, both in galleries all over the world and in his own gallery, "291."[14] The culminating exhibition of this great series was held at the Albright Art Gallery, Buffalo Fine Arts Academy, in 1910.[15]

All these events were recorded in another of Stieglitz's weapons against artistic ignorance, his quarterly magazine *Camera Work*, which he founded, edited, and published in fifty numbers from its inception in 1903 until its end in 1917. For the most part its reproductions were photogravures, on Japanese tissue, that often surpassed the original photographs from which they had been made. They set a standard of plate quality which remains un-

14. In its first years (1902–1904) the Photo-Secession had no gallery. The Little Galleries of the Photo-Secession at 291 Fifth Avenue, New York, later known as "291," began in 1905 for the purpose of showing the best in photography. Paintings were first shown there in 1907, others followed.

15. The Albright exhibition may be said to represent a high point as well as an end point of the Photo-Secession's major activities as a group for photography. Hung by Stieglitz, Max Weber, Paul B. Haviland, and Clarence H. White, the show was a spectacular success, climaxed by the purchase of a group of Photo-Secession prints for the Museum's collections.

excelled today in American periodicals.[16] Described by Lloyd Goodrich as *"the most radical American magazine of arts and letters,"*[17] it included not only the work of photographers Stieglitz believed important but also a record of events at "291" which introduced modern art to the United States.

Increasingly, in the later "291" years, Stieglitz turned more to the creation of his own photographs and his activities on behalf of modern art, using "291" as a place to present to the American public work he believed significant in all media. One reason he became interested in modern art was that it seemed to him the opposite of what was being done in photography. He sensed a new direction in the works by Rodin, Matisse, and Picasso, which he had been showing at "291" since 1908—a direction with a reality of its own entirely different in form and emphasis from that of the camera. And when Stieglitz wrote in 1913 (in support of the forthcoming Armory Show), that the *"dry bones of a dead art are rattling as they never rattled before,"* possibly he was thinking of photography as well as painting.

Although the Photo-Secession never dissolved formally, it gradually ceased as a group. Stieglitz continued, however, to show new photographic work when he believed it was important, such as the work of Paul Strand, and later that of Ansel Adams and of Eliot Porter. It was all part of his fight for photography, but the battleground and the participants had changed.

MEANWHILE, in addition to his Photo-Secession activities, Stieglitz had continued to photograph. He made relatively few prints in the "291" years, but they mark a transition from his youthful preoccupation with techniques and wide subject matter to a concentration on the material closest to his daily life. They were made because he had something to say. Whereas his earliest prints had been of things that interested him here and there, the important prints of the last "291" years and the years to come were of acutely living things. Straight photography and the contact print had become the only means possible for attaining his photographic goals. As his direction crystallized, his way of working fused with his way of seeing. The "291" years represent more than any others a time during which Stieglitz clarified for himself the essence of photography.

His most important prints surviving from the Photo-Secession period are platinum prints of singular, dark beauty, made from 8 × 10 inch negatives. Two themes run through virtually all of them: one, a group of the city and its changes; the other, a group of portraits of Stieglitz's friends. Finally, a few additional outstanding prints are of art exhibitions held at "291" in which the presentation and content of the shows are used as abstract elements in the photograph (e.g., the Braque-Picasso Exhibition at "291," No. 90A).

In contrast to the exciting New York of the 1890's, which Stieglitz was impelled to photograph right down on its streets, the large "291" New York prints are nearly all made from three floors up, from the back windows of "291" (Plates 11 and 12, "From the Window—'291'," No. 90D and No. 13A) and from that one point of view show an infinite variety, anticipating the work to come from his even higher city windows in the 1930's. It was the start of his photographing his world from one place, seen many ways. The juxtaposition of "old" and "new" New York,

16. In 1924 the Royal Photographic Society of Great Britain conferred on Stieglitz its Progress Medal, the highest honor in the photographic world, for *"services rendered in founding and fostering Pictorial Photography in America, and particularly for your initiation and publication of* Camera Work, *the most artistic record of Photography ever attempted."*

17. *Pioneers of Modern Art in America, The Decade of the Armory Show, 1910–1920.* New York, 1963.

the brownstone city changing to a modern city, first stated clearly in his prints of 1910, continues to touch him but is more subtly expressed in the 1914–15 series. The city he recorded in these years of the war was dark, sad, beautiful, and changing.

The human subjects of the period are no longer strangers Stieglitz saw passing by but are friends and associates he knew well. Many of these prints move to the heart of their subject with an inner authority that foreshadows the feeling of his later portraits but which only occasionally existed in earlier years. Made on platinum paper, the portraits, both of persons and of the city, have a brooding poetic quality, as well as one of great loneliness.

If Stieglitz had never made any prints after 1917, the body of his work would then have been sufficient to secure his place in photographic history. It was, however, a turning point in his life and work. The war years had been difficult for Stieglitz in many ways. *Camera Work*, known and admired since 1903, now came to an end with a total of 37 subscribers. With a full sense of the irony of his actions, Stieglitz burned and gave away copies to be rid of it and sold hundreds of copies of the elegant magazine *291* as waste paper at ten cents a pound. The building of "291" was to be torn down. He had no gallery, and felt his life at a low ebb.

III. Late Period (1917–1937)

WHEN "291" ended in 1917, Stieglitz was free, for the first time since 1905, to photograph without the strain of constant exhibitions. It was also in 1917 that he first met Georgia O'Keeffe, although he had exhibited her drawings at "291" in 1916, before he knew her. No intelligent consideration of his later photographs can be made without mention of his relationship to O'Keeffe, for this remained the center of his life and work until his death in 1946.

The important photographs of Stieglitz's late period can be grouped into five principal subjects, each of which can be considered independently although they are all basically related: the O'Keeffe portrait; the clouds ("Equivalents"); the Lake George prints; the large portraits; and the large New York prints. Taken as a whole, the Stieglitz prints of these years have a beauty and emotional power unmatched in his earlier work. The 1917–29 prints especially are like a rich and wonderful flowering of a man: the mature artist at his peak of eloquence.

The prints of the 1930's are subtly different. The pure, lyric quality of the early twenties is often changed by a starker tone difficult to define. In these later prints one is touched more by the very old, the very experienced artist, who has integrated the wisdom of age with the vitality and excitement of the young.

The Stieglitz photographs of these later years are basically one thing said many ways. Prints of the clouds, landscapes, friends, are closely akin to each other. Their nature is determined more by his feelings at a particular time than by their subject matter. The prints of 1929, for instance, have a special character which makes them unlike those of any other year. And the clouds of 1931 resemble his 1931 prints of the city more than they resemble his 1923 clouds. The formal portraits of his friends, particularly those done in the 1920's, have a dimension of insight more penetrating than those of the "291" years. The large New York prints, all of which were made in the 1930's, are taken from the windows of the places where he lived and worked. In his youth Stieglitz had photographed the city from its streets; in the later Photo-Secession years he worked from the top of the brownstone at 291 Fifth Avenue; now he looked out always from skyscrapers, principally the upper floors of the Shelton Hotel (Plate 58, "From the Shelton, Looking Northwest," No. 2D; and Plate 60, "From the Shelton, Looking West," No. 3D),

and the seventeenth floor of 509 Madison Avenue (Plate 55, "From An American Place, Looking North," No. 9B). The human element so prominent in his New York photographs of the 1890's has vanished. What remains in the city prints of the 1930's is the antihuman city of brilliant steel and stone, sunlight, shapes, and shadows.

After "291" came to an end, the first series in which Stieglitz became absorbed was the portrait of Georgia O'Keeffe. Starting in 1917 and continuing until he put down his heavy cameras in 1937, the O'Keeffe portrait as he left it consists of prints from about 500 negatives. Ideally, Stieglitz believed that a photographic portrait should begin with birth, continue throughout life until death, and then continue with the subject's child. To show the many facets of a person, the true portrait had to be many prints which, seen together, would convey more than the same photographs seen one at a time. Hands, feet, torsos, tones and lines, molded by every possible experience, mood, and emotion—taken over the years—all belonged. His concept was challenging and impossible, but he came nearer to achieving it in his photographs of O'Keeffe than in any other group of his prints. Although the Stieglitz portrait of O'Keeffe inevitably has its roots in the photographer and his subject, the series of prints transcends the two individuals concerned and becomes a moving symbol of the range of possibilities, life, and beauty inherent in human relationships.

His abstract sense was true, but its use in his work developed very gradually. An early example of its relatively unconscious use can be seen as far back as 1887 (e.g., "Sterzing, 1887?" No. 59A). Later on, the Photo-Secession years coincided with an overturning of traditional modes of expression in painting—a revolution in which Stieglitz played a prominent role. Living in daily contact with the new European and American art he was showing at "291" may have caused him to look more critically at his own photographs and given impetus to the abstract element in his work. It was not really until the photographs of O'Keeffe made in 1918, however, that he began consciously to make a line, a shape, or a tone speak with their own meanings. From that time on his use of abstraction pervades the prints he made until the end of his life, although it reaches its most deliberate extension in the cloud photographs.

O'Keeffe's early strength and certainty in the abstract idiom, evolved during her years in Texas and the South (1914–1916), may be mentioned as another possible influence on Stieglitz's work, since abstraction first reaches its consistently expressive use in his photography only after 1917. The interaction between two formed, independent, and creative persons' work, such as Stieglitz's photographs and O'Keeffe's paintings, should not be underestimated.

Although Stieglitz had been photographing constantly since the closing of "291," he had held no exhibition of his work since 1913.[18] Finally, in 1921, Mitchell Kennerley, a close friend and president of the Anderson Galleries, persuaded him to let the public see his photographs once more and offered him space for an exhibition. It had become customary to think of Stieglitz as the Grand Old Man of Photography, a leading figure of its past.[19] After the 1921 exhibition this was no longer possible.

18. Characteristically, Stieglitz hung a one-man show of his photographs at "291" during the 1913 Armory Show as a test for himself of his own work, the only one-man exhibition he ever held of his own prints at "291."

19. This can be better understood if one realizes that the thirty photographs Stieglitz showed in 1913 as his evolution ranged from his early European and New York prints of the 1890's to the 1910 photogravures of changing New York, representing his newest work.

 For the 1921 exhibition Stieglitz selected twelve from the 1913 group as "early prints." Most of the others now seen publicly for the first time included: the large platinum prints of the later "291" years; the first late period portraits; and about fifty unnamed prints from the O'Keeffe portrait, made between 1918 and 1920.

 If one visualizes the prints in the 1913 and 1921 exhibitions, the distance he had traveled is astonishing.

His feelings about his recent prints, photography, and the intensity with which he had been working are suggested by his own statement in the catalogue: *"This exhibition is the sharp focussing of an idea. The one hundred and forty-five prints constituting it represent my photographic development covering nearly forty years. They are the quintessence of that development. One hundred and twenty-eight of the prints have never before been seen in public. Of these seventy-eight are the work since July, 1918. . . . The Exhibition is photographic throughout. . . . Every print I make, even from one negative, is a new experience, a new problem. For, unless I am able to vary—add—I am not interested. There is no mechanicalization, but always photography. . . .*

"I was born in Hoboken. I am an American. Photography is my passion. The search for Truth my obsession."

Intimate and daring, this first Anderson Galleries show of Stieglitz's new work was one of the sensations of the New York art season and renewed the slumbering question of whether or not photography was an art. The writings evoked focused on the prints from the O'Keeffe portrait more than any other group of prints shown. Stieglitz, hearing comments that it was his subject who made these photographs wonderful rather than the photographer, turned to photographing the skies which, as he dryly remarked, were available to everyone.

Although he often referred with seeming facetiousness to what he called his "snaps" of the clouds,[20] basically he knew the astonishing work he was doing. He wrote more seriously to Hart Crane in the fall of 1923, knowing the poet would understand: *". . . I have done some real things. All small. No portraits. No apples or barns. Only 'sky' pictures—I have driven my ideas still further & have some little prints that are truly beautiful & are new—different from anything the eye has seen in any medium.—But that happened. Life compelled me into the doing—that's all. . . ."*

And again in December, from New York: *". . . I'm most curious to see what the 'Clouds' will do to you. About six people have seen them—Men, Women, Girls & young fellows, artists & laymen—all are affected greatly and forget photography entirely—. . . .*

"I know exactly what I have photographed. I know I have done something that has never been done—. . . ."

Stieglitz set out to discover in his cloud photographs what he had learned about photography and in them recapitulated his entire life. About fifty of these small prints were first shown in 1924,[21] many as sets called "Songs of the Sky," which he described in the catalogue as *"tiny photographs, direct revelations of a man's world in the sky, documents of eternal relationship."* Always fighting for a more perfect use of photography, the balance of shapes and tones within each small print became equated with the statement of every emotional experience he knew, and the clouds became the "Equivalents." They were first shown under this title in the "Seven Americans" exhibition at the Anderson Galleries in 1925. More than any other single group of prints, more eloquent than words, the "Equivalents" are his autobiography.

Living with the materials of his art and knowing the photographic moment when it arrived had become more important to him than all else. He waited for the cloud to be there, the raindrop, the trees growing and dying year by year. He waited to photograph people he knew in the same way. He waited, seeing many prints in his mind's eye, for the exact instant when he could transform that inner vision to a tangible print, through photography.

20. Prints from about 400 negatives of the clouds remain, all made in 4 × 5 inch negative size starting in 1923. The only important exception is his first and only large set of cloud prints begun in 1921, which was shown in his second Anderson Galleries exhibition (1923) as "Music —A Sequence of Ten Cloud Photographs." (Plate 38 is the first print of this sequence.)
21. Stieglitz's third Anderson Galleries exhibition, held simultaneously with fifty-one O'Keeffe paintings.

When that moment came he wanted to be there, ready. Every important print of the late period is permeated by this intense concentration, a deepening of his relationship to his photographic quest.

The letters he writes to his friends are full of these periods of waiting, followed by bursts of photographic activity. One of the finest, again written to Hart Crane from Lake George in 1923, conveys the special quality of Stieglitz's experience and its expression in his prints. "... *There has been much excitement the last few days. A wondrous snowstorm on Sunday—snow knee deep—& a breathless stillness—the air mild—O'K & I were out all day—nothing escaped us of the feast of beauty—everywhere—at every glance. I never was so ready to see. I photographed much until I nearly collapsed —excitement & actual physical fatigue. For 50 years I had been dreaming of such a day up here—To intensify all the beauty of Nature—& of O'K who was a marvel to watch enjoying so fully—As we tramped through knee high snow to the P.O. a mile & a quarter away I found a big mail. And the letters were from far & near—& all of them matched the whiteness of the day....*"

For Stieglitz the practice of photographic techniques was inseparable from his visualization of the final print. His own development of the negative, his struggles for the finest possible print, the most perfectly balanced presentation, were all essential steps for its realization. Already by 1917 he knew the limitations of the perfection he had pursued in his negatives of the 1880's when he writes to a friend: "... *It is the intensity of feeling* expressed *which lives. It is not the technique. Technique is a dead thing, no matter how masterly it may be in itself. At first it may attract, but eventually it repels ... because it is not vital. It is like a vaudeville stunt. All right as far as it goes, & very wonderful. But it is not sufficient; if one requires from life more than surface qualities & everyone does ... even though few are conscious of it.*"

By 1920 Stieglitz was writing to Paul Rosenfeld saying that he was printing some of the greatest prints of his life from negatives he would have destroyed in his youth. He printed with a fanatic zeal, often making a hundred or more prints from a single negative before getting the one he wanted, at which point he usually destroyed the others. The illusive search for perfection is no longer the naive one of a technically perfect negative from which the perfect print would follow, it has become one of the print with an irresistible emotional impact. To reproduce the real life that he put into his best print is impossible.

Stieglitz stopped photographing in 1937 when, at the age of seventy-three, he could no longer easily handle either one of his heavy cameras. The work of his last few active years was mostly done on small negatives with his Graflex and for the first time since his student days, was inconsistent in level, as he bowed to age, illness, and the persuasions of certain friends and let a commercial firm develop some of his negatives. These last prints, for which many negatives were commercially developed, lack the full force characteristic of him.

His photographic tools were so simple that most present-day photographers would think it impossible to work with them. After 1917 he used principally two cameras, an 8 x 10 inch Eastman View camera with a Packard shutter, and a 4 x 5 inch Auto Graflex with two old but excellent Goerz lenses. In addition he had three yellow filters (K-1, K-2, K-3), three lens hoods, two old tripods, and a white cotton umbrella which he used occasionally as a reflector to lighten shadows in his portraits. At Lake George prints were washed in the bathtub and hung on a kitchen or attic clothesline to dry.

To define and fix a moment of reality, to realize the potential of black and white, through photography, fascinated Stieglitz from his first classroom photographs to the pure vision of the late prints. It is a life's work of infinite patience, discrimination, and passion.

Chronology

1864 Alfred Stieglitz born, January 1, Hoboken, New Jersey.

1871 Stieglitz family moved to New York, where Stieglitz lived until his death in 1946, except for his student years in Europe, a few subsequent summers in Europe, and summers at Lake George, New York.

1871–1882 Schooling in New York and Germany, unrelated to photography: Charlier Institute; New York Grammar School No. 55; Townsend Harris School; College of the City of New York; Realgymnasium, Karlsruhe, Germany.

1882–1890 Berlin Polytechnic Institute; University of Berlin. Shifted in 1883 from study of mechanical engineering to that of photography, photochemistry, and related subjects. First photographs made in 1883.

1886 First prints sent to competitions; first year in which he started to keep prints.

1887 Vacation trip to Italy resulting in first important body of photographs, which in later life he felt represented his earliest work of interest. First official recognition of his photographs, awarded by Dr. P. H. Emerson in *Amateur Photographer* (London) Holiday Work Competition. First year in which English and German periodicals began reproducing his photographs.

1888 More prints sent to exhibitions. Articles appeared on his work by Dr. Emerson and Dr. H. W. Vogel, prominent authorities on photography in England and Germany.

1889 Stieglitz photograph made and completed in 37 minutes at Berlin Jubilee Exhibition in the belief that speed would one day be important for press photography.

1889–1910 Constant photographing, experimenting, exhibiting, resulting in over 150 medals and prizes in important worldwide photographic exhibitions.

1890 Return to the United States to live in New York. Entered photoengraving business from which he withdrew in 1895. First year in which his work became well known in American photographic periodicals.

1891 Joined Society of Amateur Photographers of New York. Started making slides and winning prizes with them, as well as prints.

1892 First extensive use of hand camera for serious photographic work (prints of the city).

1893–1896 Work in various editorial capacities on *American Amateur Photographer*, then the foremost American photographic periodical.

1893 First successful snow photographs.

1894 Summer in Europe. Finest European prints. First successful rainy-day photographs. Unanimously elected to Linked Ring (England) membership, first American photographer so honored.

1896 First night photographs. Merger of Society of Amateur Photographers with New York Camera Club to form Camera Club of New York. Resigned editorship of *American Amateur Photographer*.

1897 Founded and edited *Camera Notes*, as organ of Camera Club of New York.

1899	Retrospective one-man exhibition at Camera Club (87 prints, 1885–1899).
1902	Resigned from *Camera Notes*. Announced formation of Photo-Secession. First exhibition of Photo-Secession as a group held at the National Arts Club, New York, to show the evolution of pictorial photography.
1903	First of fifty numbers of *Camera Work* appeared, published and edited by Stieglitz.
1904	Trip to Europe. Also in 1907, 1909, 1911 (last trip).
1905	Formation of The Little Galleries of the Photo-Secession at 291 Fifth Avenue, New York, later known as "291." About eighty exhibitions were held between 1905 and 1917, starting with the aim of showing the best in photography. Paintings and work in other media were also shown, starting in 1907.
1907	Work with Lumière autochromes (color photography) while in Europe with Edward Steichen and Frank Eugene (first Americans to use them). Occasional work in this medium until 1914. Experimental black-and-white print series with Clarence H. White.
1908	Expelled from Camera Club and soon reinstated.
1910	Organized International Exhibition of Pictorial Photography at Albright Art Gallery, Buffalo.
1913	One-man exhibition at "291" of his photographic evolution (30 prints, 1892–1911), held during Armory Show as a test for himself of his own work.
1917	End of "291." Last number of *Camera Work*. First photographs of Georgia O'Keeffe.
1918–1919	First late period photographs of Lake George and portraits.
1921	Retrospective one-man exhibition of prints at Anderson Galleries (145 prints, 1886–1921).
1923	One-man exhibition at Anderson Galleries (116 prints, 1918–1923). First small photographs of clouds that summer at Lake George.
1924	Exhibition at Anderson Galleries (61 prints, mostly work of 1923), held with 51 O'Keeffe paintings. Museum of Fine Arts (Boston) asked Stieglitz for a group of his photographs for its Print Department and received a group of twenty-seven. Progress Medal awarded by Royal Photographic Society of Great Britain.
1925	"Seven Americans" exhibition organized at Anderson Galleries by Stieglitz. Included photographs by Stieglitz and Paul Strand.
1925–1929	Intimate Gallery, Room 303, Anderson Galleries, 489 Park Avenue, New York, total of about twenty exhibitions. Paul Strand only photographer shown.
1928	Metropolitan Museum of Art asked for Stieglitz prints. They were given by a group of friends.
1929–1946	An American Place, Room 1710, 509 Madison Avenue, New York, total of about seventy-five exhibitions. Ansel Adams and Eliot Porter only new photographic work shown.

1932	One-man exhibition, An American Place (127 prints, 1892–1932), the first since 1924. Probably first time small chloride prints of New York in the 1890's were shown; first showing of large New York series (started 1931) from his high windows.
1933	Major portion of Stieglitz's collection of photographs by others from the "291" period taken by Metropolitan Museum of Art as he was about to destroy it.
1934	One-man exhibition, An American Place (69 prints, 1884–1934). Included new prints from lost negatives of early European work and recent work.
1937	Last new photographs.
1941	Museum of Modern Art received a group of Stieglitz prints.
1944–1945	Stieglitz collections of painting and photography shown at Philadelphia Museum of Art.
1946	Alfred Stieglitz died, July 13, New York.

Bibliography

THE references below have been selected with emphasis on Stieglitz as photographer. No attempt has been made to compile an exhaustive bibliography, which would necessarily include several thousand items for the most part of dubious value, for purposes of this catalogue. The *fact* that this many exist is principally interesting insofar as it suggests the degree to which Stieglitz and his activities were always storm centers.

I have omitted all references in publications Stieglitz edited, as they appear in so many numbers that anyone interested in him would have to examine complete files of these periodicals. I have included informative references of factual value, as well as some of the wildest, most emotional, and inaccurate literature which has unfortunately accumulated to form a distorted legend around Stieglitz and his work. Taken together they give a picture of him which has a richness and variety which would be lost were either category entirely excluded. The best and only facts about Alfred Stieglitz that cannot be contradicted are his photographs.

Principal Publications Edited or Published by Alfred Stieglitz

American Amateur Photographer. A monthly. New York, 1893–1896.

An American Place. New York. Exhibition catalogues, 1929–1946, many with statements of interest.

Anderson Galleries. New York. Catalogues of four exhibitions organized by Alfred Stieglitz, with statements by him, 1921, 1923, 1924, 1925.

Camera Notes. Published quarterly under Stieglitz's direction for The Camera Club of New York, 1897–1902.

Camera Work. A quarterly, issued in fifty numbers. New York, 1903–1917. Cover and marque designed by Edward Steichen. Edited and published by Alfred Stieglitz.

Intimate Gallery. New York. Exhibition catalogues, 1925–1929, many with statements of interest.

MSS. Complete in six numbers with portfolio and cover designed by Georgia O'Keeffe. New York, 1922–1923.

Photo-Secessionism and Its Opponents. Five Recent Letters. New York, August, 1910. A Sixth Letter. New York, October, 1910. Six letters published by Alfred Stieglitz.

Picturesque Bits of New York and Other Studies. Portfolio of twelve photogravures by Alfred Stieglitz, intro. by Walter E. Woodbury. New York, 1898.

Edward Steichen. Selected proofs of his photographic work from *Camera Work*, with preface by Maurice Maeterlinck. Published by Alfred Stieglitz. New York, 1906.

291. Complete in twelve numbers. New York, 1915–1916.

"291." [The Little Galleries of the Photo-Secession.] New York. Exhibition catalogues, 1905–1917, assembled and bound by Alfred Stieglitz. Three known copies in existence (no two quite alike), of which one is in the Alfred Stieglitz Archive in Yale University's Collection of American Literature.

Representative Selection of Material about Alfred Stieglitz

Academy Notes (Buffalo Fine Arts Academy). January, 1911.

"Alfred Stieglitz, Artist, and his Search for the Human Soul." *New York Herald*, March 8, 1908.

Anderson, Sherwood. *Sherwood Anderson's Notebook*. New York, 1926.

Barnes, Djuna. "Giving Advice on Life and Pictures. . . ." *Morning Telegraph*, February 25, 1917.

Bruno, Guido. "The Passing of '291'." *Pearson's Magazine*, March, 1918.

Bry, Doris. "The Stieglitz Archive at Yale University." *Yale University Library Gazette*, April, 1951.

———. *Alfred Stieglitz: Photographer*. National Gallery of Art, Washington, D.C., 1958. Catalogue of an exhibition from the key set.

———. Definitive catalogue of Stieglitz photographs, in progress.

Buffalo Fine Arts Academy, Albright Art Gallery. Catalogue of the International Exhibition of Pictorial Photography. Organized by Alfred Stieglitz and the Photo-Secession. Buffalo, 1910.

Caffin, Charles H. *Photography As a Fine Art*. New York, 1901.

"Camera Club Ousts Alfred Stieglitz." *New York Times*, p. 1, February 14, 1908.

Carnegie Institute, Pittsburgh. A Collection of American Pictorial Photographs. Catalogue arranged by Alfred Stieglitz. Cover designed by Edward Steichen. Pittsburgh, 1904.

Coomaraswamy, Ananda. "A Gift from Mr. Alfred Stieglitz." *Museum of Fine Arts Bulletin* [Boston], April, 1924.

Dreiser, Theodore. "A Master of Photography. . . ." *Success*, June 10, 1899.

Engelhard, Georgia. "The Face of Alfred Stieglitz." *Popular Photography*, September, 1946.

Ernst, Agnes. "New School of the Camera. . . ." *New York Sun*, April 26, 1908.

Frank, Waldo, and Lewis Mumford, Dorothy Norman, Paul Rosenfeld, Harold Rugg, eds. *America and Alfred Stieglitz, a Collective Portrait*. New York, 1934.
———. *Our America*. New York, 1919.

Gernsheim, Helmut, with Alison Gernsheim. *The History of Photography*. London and New York, 1955.

Goodrich, Lloyd. *Pioneers of Modern Art in America, The Decade of the Armory Show, 1910–1920*. New York, 1963.

[Hartmann, Sadakichi]. "Gessler's Hat." *The Camera*, November, 1904. [Written under pseud. Caliban.]

Haz, Nicholas. "Alfred Stieglitz, Photographer." *The American Annual of Photography*. Boston, 1936.

Hoge, F. Huber. "King of the Camera." *Illustrated Buffalo Express*, January 22, 1899.

Ivins, William M., Jr. "Photographs by Alfred Stieglitz." *Bulletin of the Metropolitan Museum of Art* [New York], February, 1929.

[Jewell, Edward Alden]. "Alfred Stieglitz" [Editorial]. *New York Times*, July 14, 1946.

Jewell, Edward Alden. "Hail and Farewell." *New York Times*, June 15, 1947.

Marks, Robert. "Man With a Cause." *Coronet*, September, 1938.

[McBride, Henry & Swift?]. "Art Photographs and Cubist Painting." *Sun*, March 3, 1913.

[McCausland, Elizabeth]. "Stieglitz's 50-Year Fight for Photography Triumphant." *Springfield Sunday Union and Republican* [Springfield, Mass.], May 14, 1933.

Moore, Clarence B. "Leading Amateurs in Photography." *Cosmopolitan*, February, 1892.

Mumford, Lewis. "A Camera and Alfred Stieglitz." *New Yorker*, December 22, 1934.

National Arts Club, New York. Catalogue of an Exhibition of American Pictorial Photography arranged by the Photo-Secession. 1902.

Newhall, Beaumont. *The History of Photography from 1839 to the Present Day*. (rev. ed.). New York, 1964.

[New York] The Camera Club. Catalogue of retrospective exhibition of eighty-seven Stieglitz photographs. Introduction by Joseph T. Keiley. New York, 1899.

Norman, Dorothy, ed. *Twice A Year*. No. 1, 5–6, 8–9, 10–11, 14–15. New York, 1938–1948.
———. *Alfred Stieglitz*. New York, 1960.

O'Keeffe, Georgia. "Stieglitz: His Pictures Collected Him." *New York Times Magazine*, December 11, 1949.

Rosenfeld, Paul. *Port of New York*. New York, 1924.

Seligmann, Herbert J. *Alfred Stieglitz Talking. Notes on Some of His Conversations, 1925–1931, with a Foreword*. New Haven, 1966.

Steichen, Edward. "The Lusha Nelson Photographs of Alfred Stieglitz." *U.S. Camera*, February–March, 1940.

Stieglitz, Alfred. "A Natural Background for Out-of-Door Portraiture" and "Night Photography with the Introduction of Life," in *American Annual of Photography and Photographic Times Almanac for 1898*. New York, 1897.
———. "The Fiasco at St. Louis." *Photographer*, August 20, 1904.
———. "The Photo-Secession—Its Objects." *Camera Craft*, August, 1903.
———. "Simplicity in Composition," in *The Modern Way in Picture Making*. Rochester, 1905.

Stone, Gray. "The Influence of Alfred Stieglitz on Modern Photographic Illustration." *American Photography*, April, 1936.

Sweeney, James Johnson. "Rebel With a Camera." *New York Times Magazine*, June 8, 1947.

Taylor, Francis Henry. [Discussion of Alfred Stieglitz and his work with review of book about him.] *Atlantic*, January, 1935.

Wilson, Edmund. *The American Earthquake*. New York, 1958.

Yellott, Osborne I. "The Rule or Ruin School of Photography." *Photo Era*, November, 1901.

Catalogue

All of the Stieglitz prints in the Museum of Fine Arts are listed below. The sixty-two photographs are all illustrated in actual size; the seven photogravures are not shown. Dates and sizes (in inches) given are those of his negatives, insofar as known, except for the photogravures, all of which come from 4 x 5 inch negatives. In those instances in which Stieglitz used conflicting dates, the most likely one has been selected. The print identification number in brackets refers to that in my complete catalogue of the Stieglitz photographs.

1. *Sun Rays – Paula – Berlin.* 1889(?).
 Silver, 7 x 9⅜ [55E], Acc. no. 50.822.

2. *The Terminal* (New York). 1892.
 Silver, 4 x 5 [128 B], Acc. no. 24.1739.

3. *At Anchor.* 1894. Silver, 7 x 9⅜ [65A], Acc. no. 50.823.

4. *Laundry, Venice.* (?).
 Silver, 4 x 5 [107A], Acc. no. 50.824.

5. *A Wet Day on the Boulevard* (Paris). 1894.
 Silver, 4 x 5 [109A], Acc. no. 50.825.

6. *Reflections – Night* (New York). 1896(?).
 Silver, 4 x 5 [128D], Acc. no. 50.827.

7. *The Hand of Man* (Long Island City, New York). 1902.
 Silver, 4 x 5 [123A], Acc. no. 24.1740.

8. *The Steerage.* 1907. Silver, 4 x 5 [125D], Acc. no. 50.826.

9. *Oscar Bluemner.* 1913(?). Platinum, 8 x 10 [87D], Acc. no. 50.836.

10. *Marsden Hartley.* 1913 (?).
 Silver, 8 x 10 [31D], Acc. no. 24.1719.

11. *From the Window – "291"* (1). 1915.
 Platinum, 8 x 10 [90D], Acc. no. 24.1738.

12. *From the Window – "291"* (2). 1915.
 Platinum, 8 x 10 [13A], Acc. no. 50.835.

13. *Georgia O'Keeffe: A Portrait* (1). 1918.
 Palladium, 8 x 10 [OK-19E], Acc. no. 24.1724.

14. *Georgia O'Keeffe: A Portrait* (2). 1918.
 Palladium, 8 x 10 [OK-33D], Acc. no. 24.1727.

15. *Georgia O'Keeffe: A Portrait* (3). 1918.
 Platinum, 4 x 5 [OK-515D], Acc. no. 1995.695.
 The Alfred Stieglitz Collection, Gift of the Georgia O'Keeffe Foundation, Jesse H. Wilkinson Fund, and M. & M. Karolik Fund.

16. *Georgia O'Keeffe: A Portrait* (4). 1918.
 Silver, 4 x 5 [OK-511E], Acc. no. 1995.694.
 The Alfred Stieglitz Collection, Gift of the Georgia O'Keeffe Foundation, Sophie M. Friedman Fund, and Lucy Dalbiac Luard Fund.

17. *Georgia O'Keeffe: A Portrait* (5). 1919.
 Palladium, 8 x 10 [OK-34E], Acc. no. 24.1731.

18. *Georgia O'Keeffe: A Portrait* (6). 1919.
 Palladium, 8 x 10 [OK-24E], Acc. no. 1995.692.
 The Alfred Stieglitz Collection, Gift of the Georgia O'Keeffe Foundation and M. & M. Karolik Fund.

19. *Georgia O'Keeffe: A Portrait* (7). 1920.
 Silver, 8 x 10 [OK-18C], Acc. no. 1995.690.
 The Alfred Stieglitz Collection, Gift of the Georgia O'Keeffe Foundation and M. & M. Karolik Fund.

20. *Georgia O'Keeffe: A Portrait* (8). 1920.
 Palladium, 8 x 10 [OK-3B], Acc. no. 24.1728.

21. *Georgia O'Keeffe: A Portrait* (9). 1920.
 Silver, 4 x 5 [OK-515E], Acc. no. 24.1736.

22. *Georgia O'Keeffe: A Portrait* (10). 1921.
 Palladium, 8 x 10 [OK-16D], Acc. no. 24.1725.

23. *Georgia O'Keeffe: A Portrait* (11). 1921(?).
 Silver, 4 x 5 [OK-503B], Acc. no. 1995.693.
 The Alfred Stieglitz Collection, Gift of the Georgia O'Keeffe Foundation, Ernest W. Longfellow Fund, and Francis Welch Fund.

24. *Georgia O'Keeffe: A Portrait* (12). 1922.
 Silver, 8 x 10 [OK-12E], Acc. no. 1995.689.
 The Alfred Stieglitz Collection, Gift of the Georgia O'Keeffe Foundation and Ernest W. Longfellow Fund.

25. *Georgia O'Keeffe: A Portrait* (13). 1922.
 Palladium, 8 x 10 [OK-40B], Acc. no. 24.1726.

26. *Georgia O'Keeffe: A Portrait* (14). 1923.
 Silver, 4 x 5 [OK-509B], Acc. no. 24.1723.

27. *Georgia O'Keeffe: A Portrait* (15). 1930.
 Silver, 8 x 10, [OK-23C], Acc. no. 1995.691.
 The Alfred Stieglitz Collection, Gift of the Georgia O'Keeffe Foundation and M. & M. Karolik Fund.

28. *Charles Duncan.* 1919.
 Palladium, 8 x 10 [29E], Acc. no. 50.837.

29. *Dorothy True.* 1919.
 Silver, 8 x 10 [40D], Acc. no. 24.1720.

30. *Georgia Engelhard.* 1921.
 Silver, 8 x 10 [55B], Acc. no. 24.1721.

31. *Helen Freeman.* 1921.
 Palladium, 8 x 10 [81C], Acc. no. 24.1729.

32. *Margaret Treadwell.* 1921.
 Palladium, 8 x 10 [83A], Acc. no. 24.1722.

33. *Apple and Drops of Rain, Lake George.* 1921(?).
Silver, 4 x 5 [192E], Acc. no. 24.1735.

34. *Dancing Trees.* 1921.
Palladium, 8 x 10 [23A], Acc. no. 24.1734.

35. *John Marin.* 1922.
Palladium, 8 x 10 [34C], Acc. no. 24.1718.

36. *Portrait of A.W.* 1922.
Palladium, 8 x 10 [82D], Acc. no. 24.1730.

37. *Chicken House, Lake George.* 1922.
Silver, 8 x 10 [19D], Acc. no. 24.1737.

38. *Music.* A Sequence of Ten Cloud Photographs (No. 1). 1922.
Silver, 8 x 10 [27B], Acc. no. 24.1732.

39. *Songs of the Sky,* in Five Pictures (No. 1). 1923.
Silver, 4 x 5 [163B], Acc. no. 24.1733.1.

40. *Songs of the Sky* (No. 2). 1923.
Silver, 4 x 5 [163A], Acc. no. 24.1733.2.

41. *Songs of the Sky* (No. 3). 1923.
Silver, 4 x 5 [160D], Acc. no. 24.1733.3.

42. *Songs of the Sky* (No. 4). 1923.
Silver, 4 x 5 [162B], Acc. no. 24.1733.4.

43. *Songs of the Sky* (No. 5). 1923.
Silver, 4 x 5 [161D], Acc. no. 24.1733.5.

44. *Spiritual America.* 1923.
Silver, 4 x 5 [155C], Acc. no. 50.855.

45. *Chicken House Window with Snow, Lake George.* 1923.
Silver, 8 x 10 [43C], Acc. no. 50.842.

46. *Portrait of R.* 1923(?).
Silver, 4 x 5 [214B], Acc. no. 50.845.

47. *Side of Barn, Lake George.* 1923(?).
Silver, 4 x 5 [240E], Acc. no. 50.846.

48. *Equivalent.* 1926(?). Silver, 4 x 5 [155B], Acc. no. 50.854.

49. *Chestnut Trees, Lake George.* 1927.
Silver, 8 x 10 [27A], Acc. no. 50.841.

50. *Equivalent,* Set G, No. 1. 1929.
Silver, 4 x 5 [166E], Acc. no. 50.850.

51. *Equivalent,* Set G, No. 2. 1929.
Silver, 4 x 5 [167A], Acc. no. 50.851.

52. *Equivalent,* Set G, No. 3. 1929.
Silver, 4 x 5 [167C], Acc. no. 50.852.

53. *Equivalent.* 1929(?). Silver, 4 x 5 [175A], Acc. no. 50.856.

54. *Equivalent.* 1930. Silver, 4 x 5 [152E], Acc. no. 50.853.

55. *From An American Place, Looking North.* 1931.
Silver, 8 x 10 [9B], Acc. no. 50.849.

56. *Poplar Trees, Lake George.* 1932(?).
Silver, 8 x 10 [23E], Acc. no. 50.840.

57. *Cary Ross.* 1932. Silver, 8 x 10 [49E], Acc. no. 50.838.

58. *From the Shelton, Looking Northwest.* 1932(?).
Silver, 8 x 10 [2D], Acc. no. 50.847.

59. *Lilac Bushes with Grass, Lake George.* 1933.
Silver, 8 x 10 [44E], Acc. no. 50.843.

60. *From the Shelton, Looking West.* 1933(?).
Silver, 8 x 10 [3D], Acc. no. 50.848.

61. *Porch with Grapevine, Lake George.* 1934.
Silver, 8 x 10 [14B], Acc. no. 50.839.

62. *Poplars, Lake George.* (?).
Silver, 4 x 5 [195A], Acc. no. 50.844.

Photogravures
(*measurements of* print *given*)

1. *The Terminal* (New York). 1892.
10 x 13⅛ [128B], Acc. no. 50.832.

2. *Spring Showers* (New York). 1900(?).
12⅛ x 5 [127A], Acc. no. 50.831.

3. *The Street – Design for a Poster* (New York). (?)
12⅛ x 9¼ [122B], Acc. no. 50.828.

4. *The Flatiron* (New York). (?).
12⅛ x 6⅝ [130B], Acc. no. 50.833.

5. *The Hand of Man* (Long Island City, New York). 1902.
9½ x 12½ [123A], Acc. no. 50.829.

6. *The Steerage.* 1907. 13⅛ x 10½ [125D], Acc. no. 50.830.

7. *The City of Ambition* (New York). 1910.
13⅜ x 10¼ [130D], Acc. no. 50.834.

Plates

1. Sun Rays – Paula – Berlin. 1889(?)

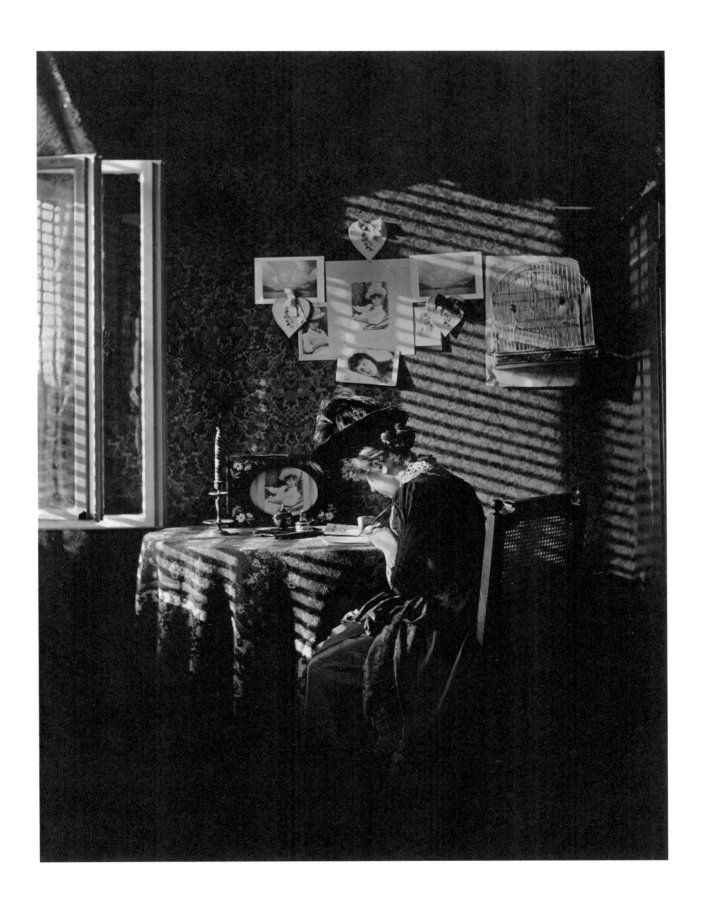

2. The Terminal (New York). 1892

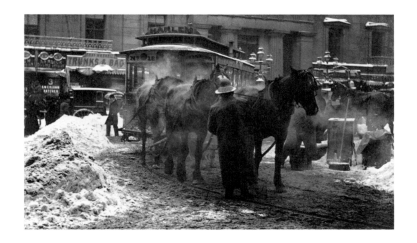

3. At Anchor. 1894

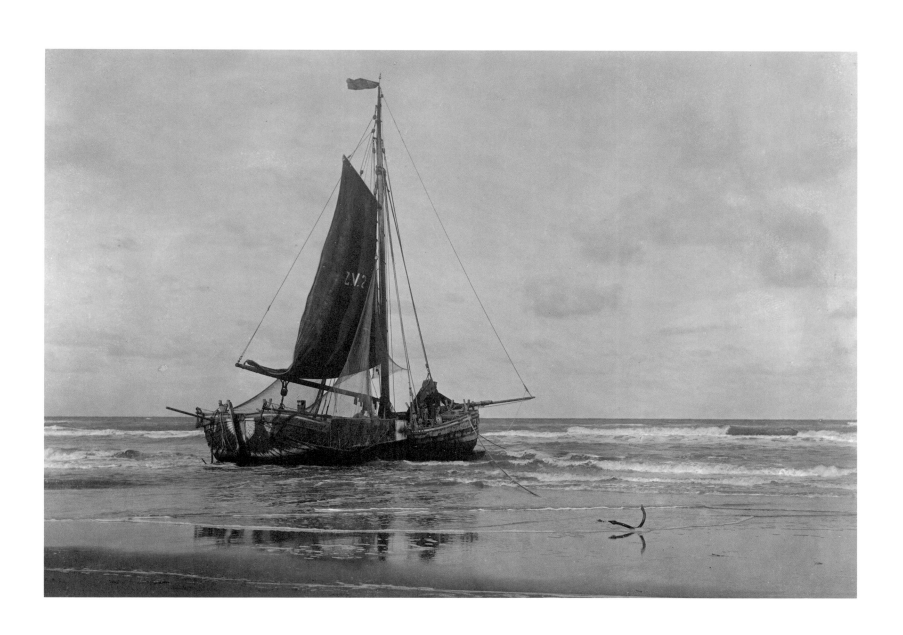

4. Laundry, Venice. (?)

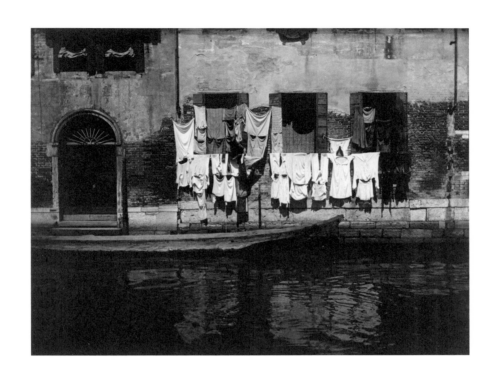

5. *A Wet Day on the Boulevard (Paris).* 1894

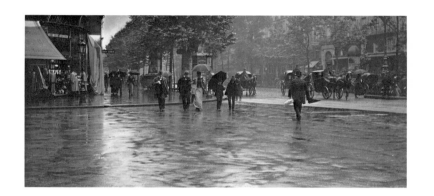

6. Reflections – Night (New York). 1896(?)

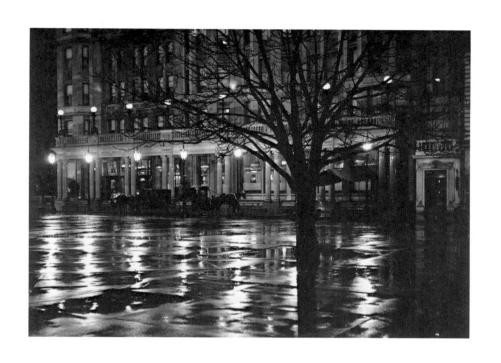

7. *The Hand of Man (Long Island City, New York). 1902*

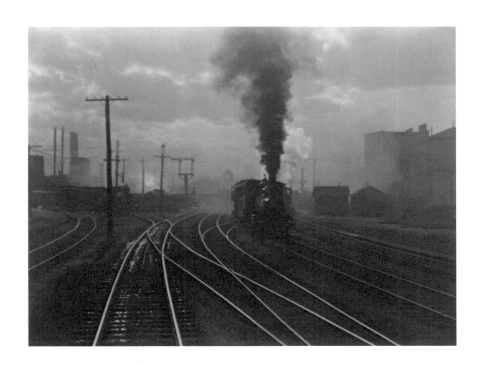

8. The Steerage. 1907

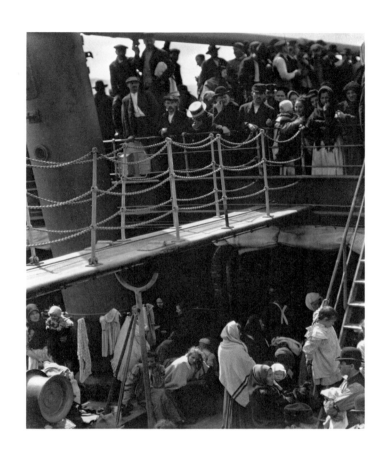

9. Oscar Bluemner. 1913(?)

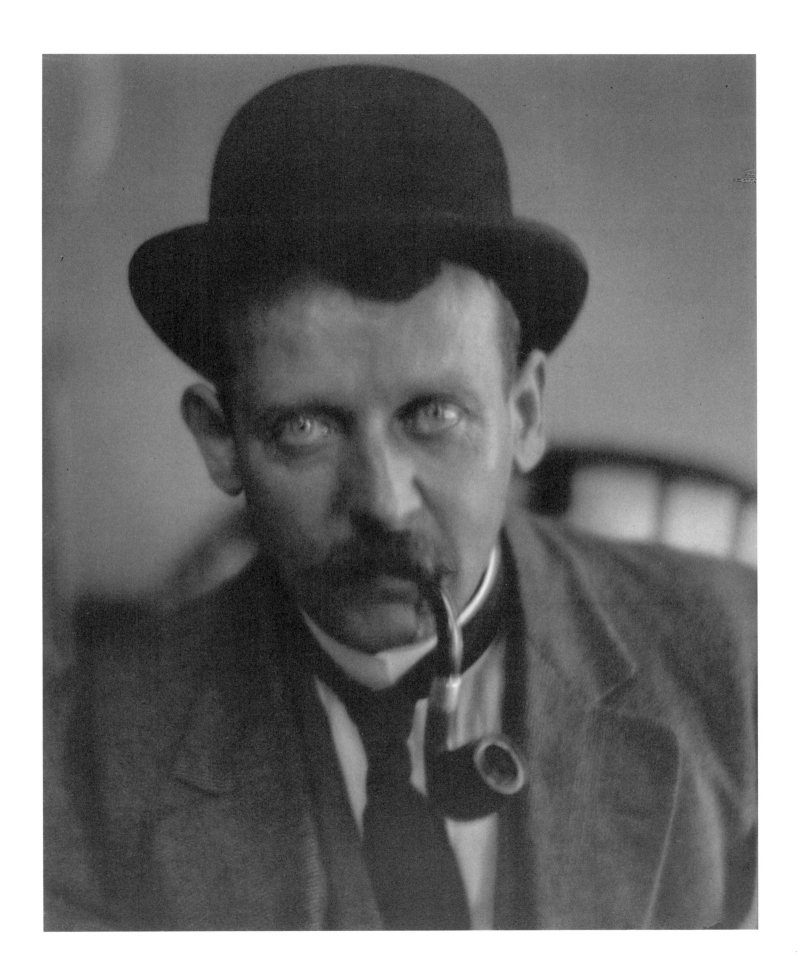

10. Marsden Hartley. 1913(?)

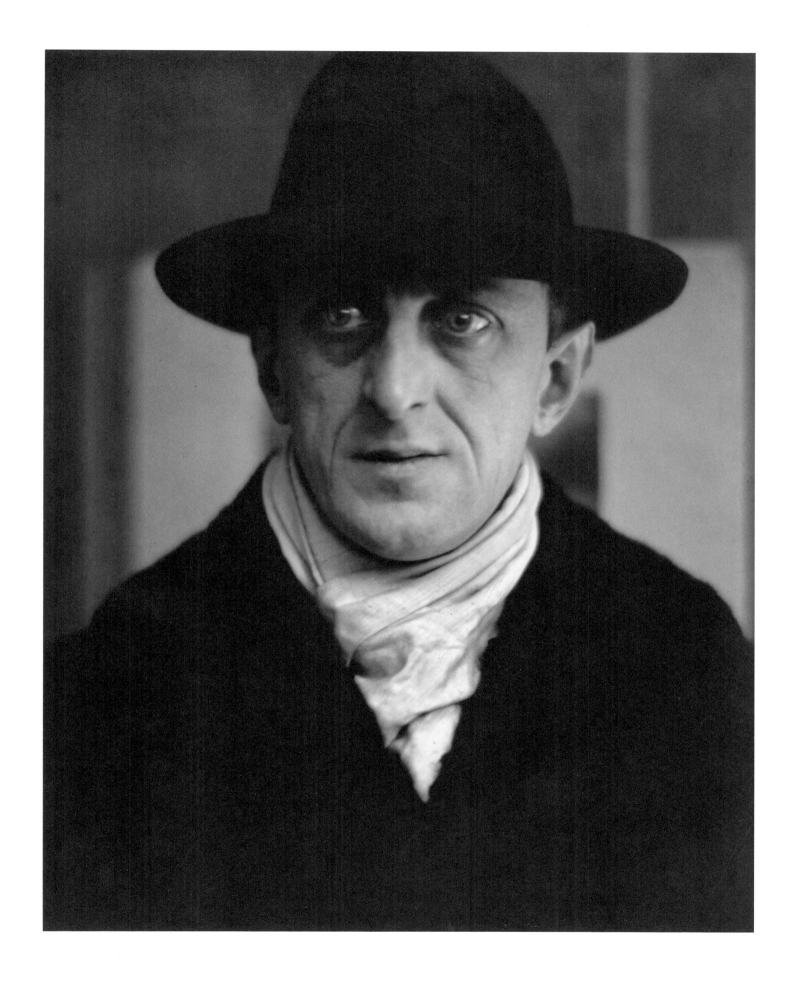

11. From the Window – "291" (1). 1915

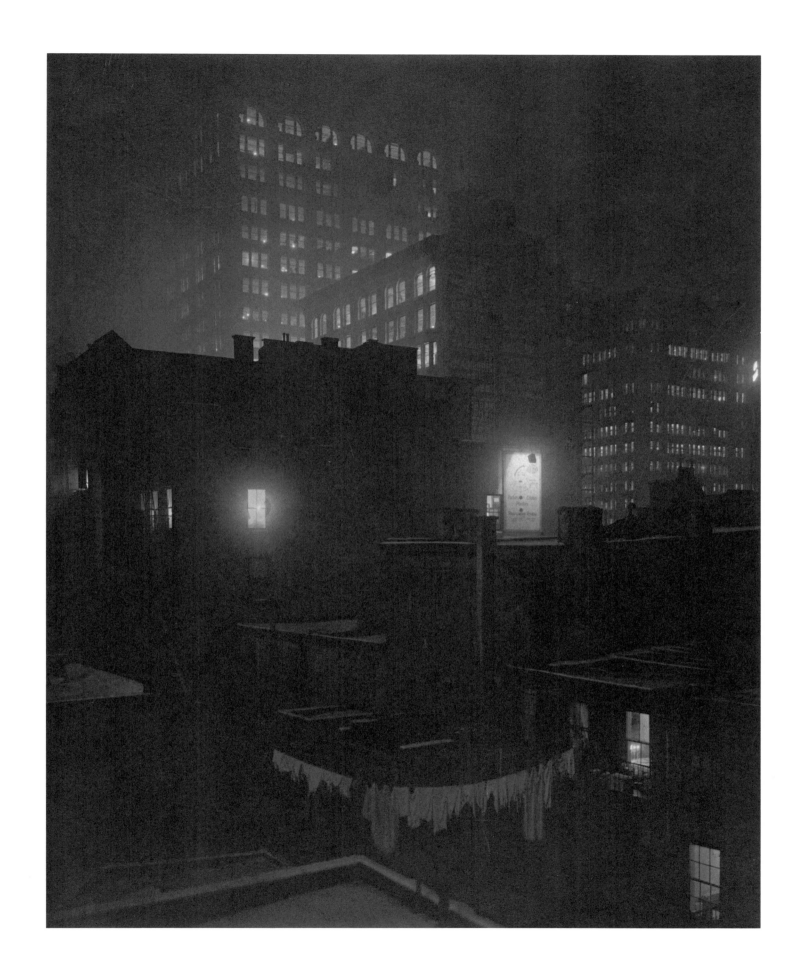

12. *From the Window — "291" (2). 1915*

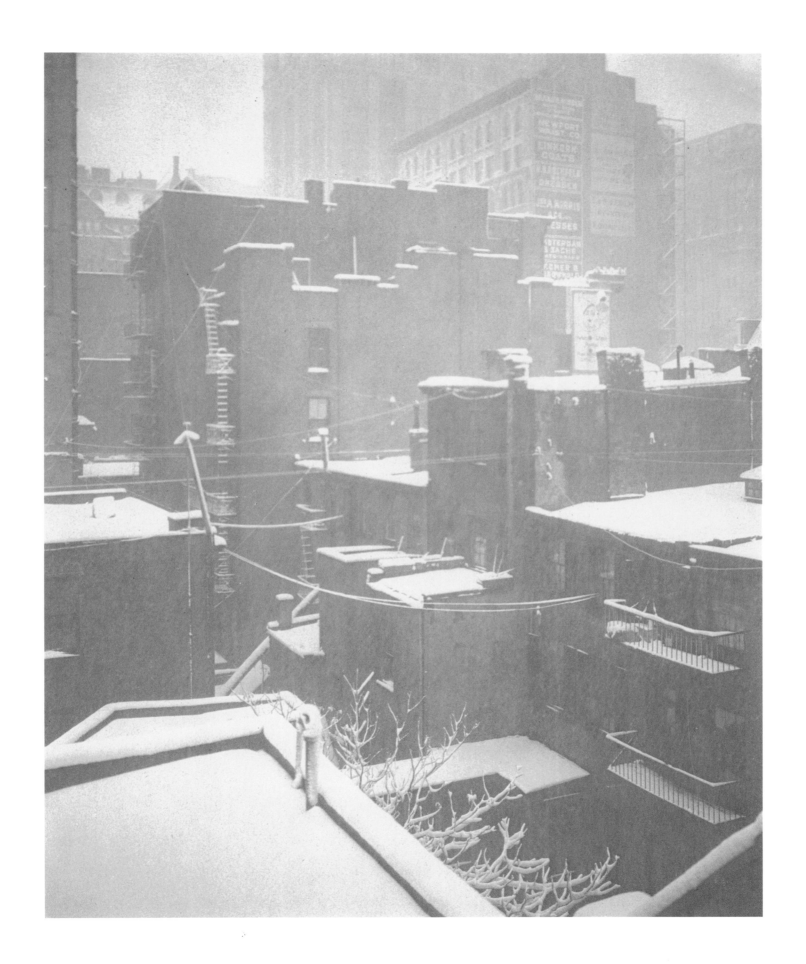

13. Georgia O'Keeffe: A Portrait (1). 1918

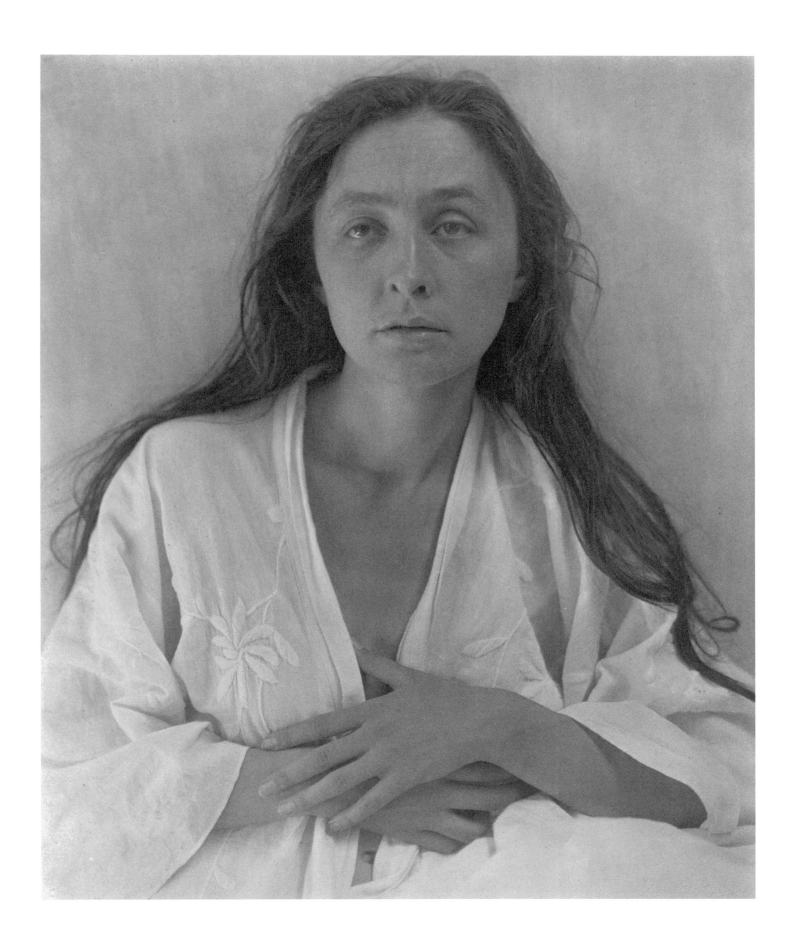

14. Georgia O'Keeffe: A Portrait (2). 1918

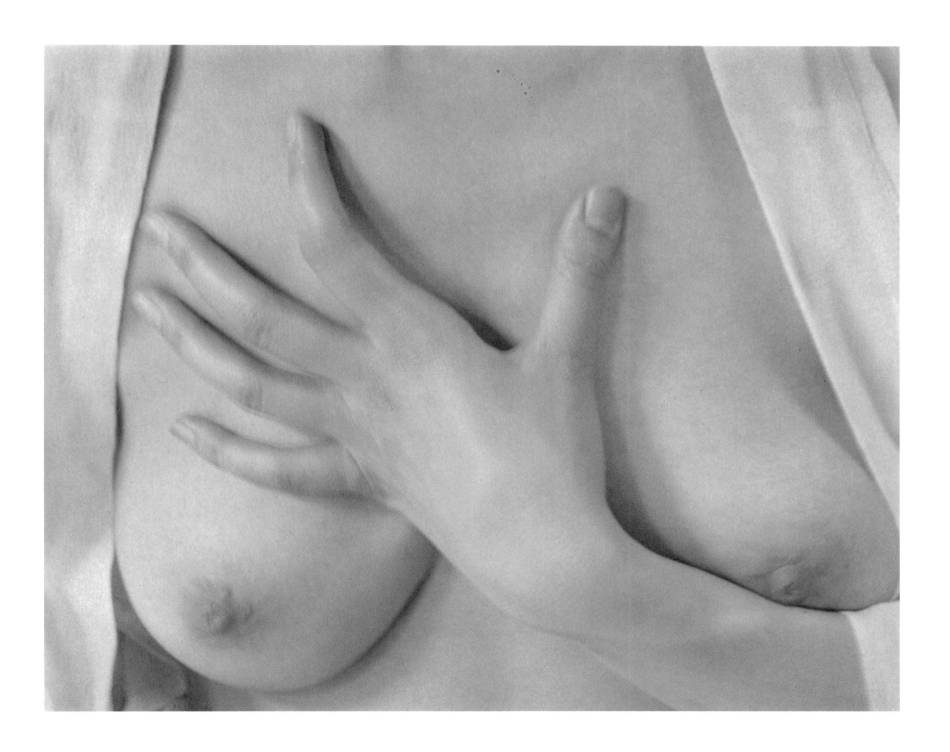

15. Georgia O'Keeffe: A Portrait (3). 1918

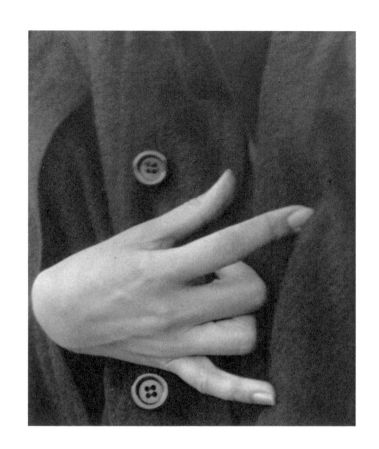

16. Georgia O'Keeffe: A Portrait (4). 1918

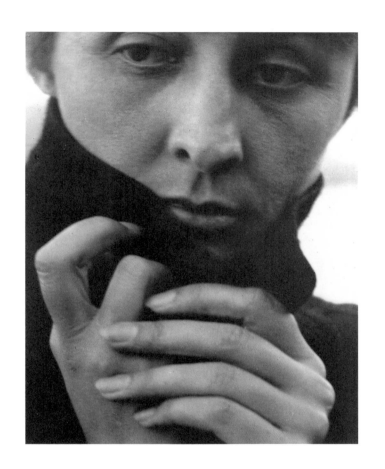

17. *Georgia O'Keeffe: A Portrait* *(5).* *1919*

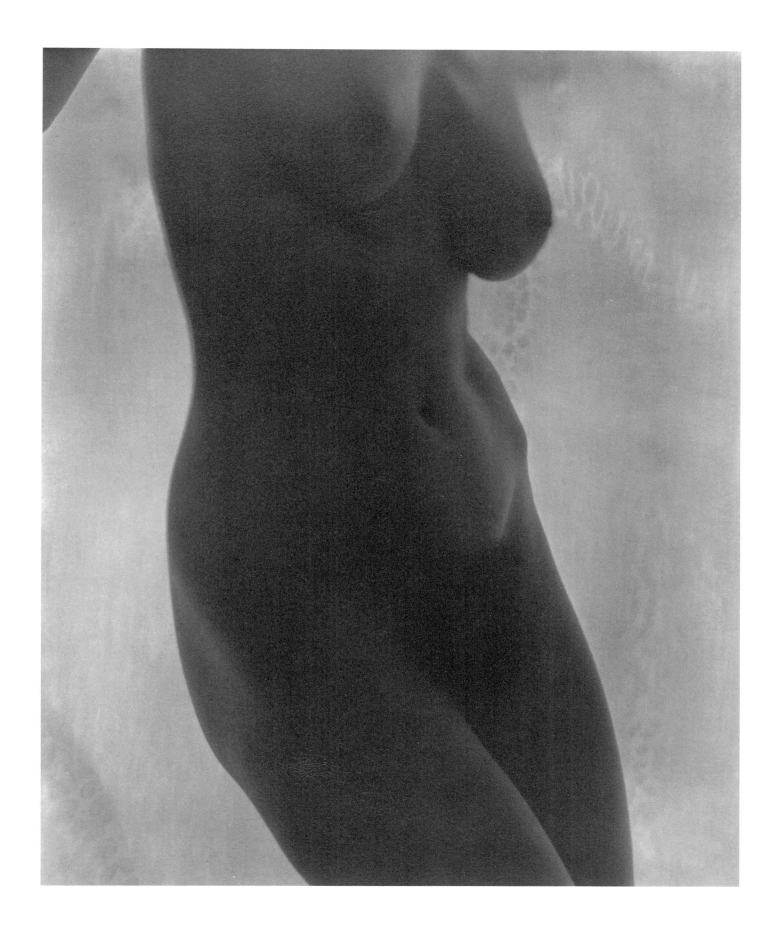

18. Georgia O'Keeffe: A Portrait (6). 1919

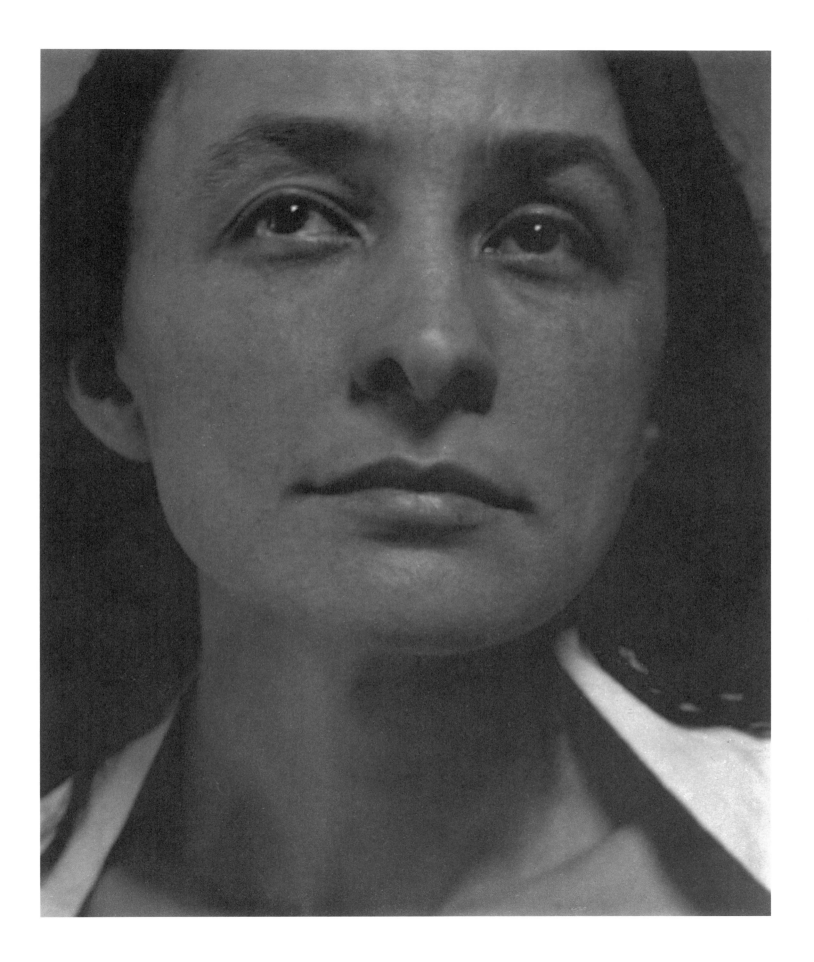

19. Georgia O'Keeffe: A Portrait (7). 1920

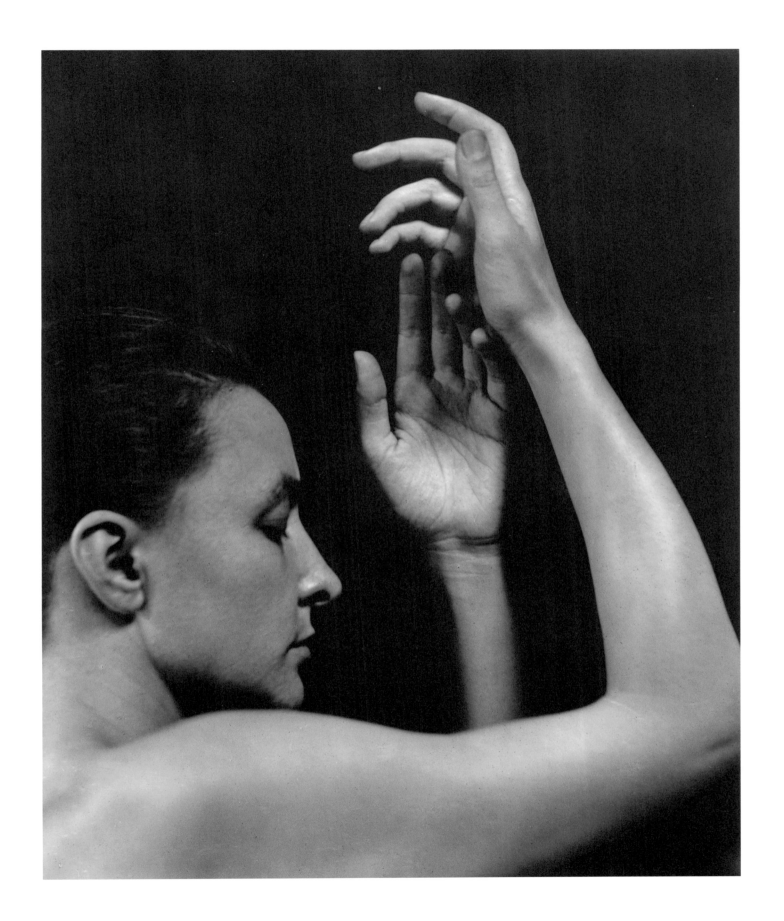

20. *Georgia O'Keeffe: A Portrait (8). 1920*

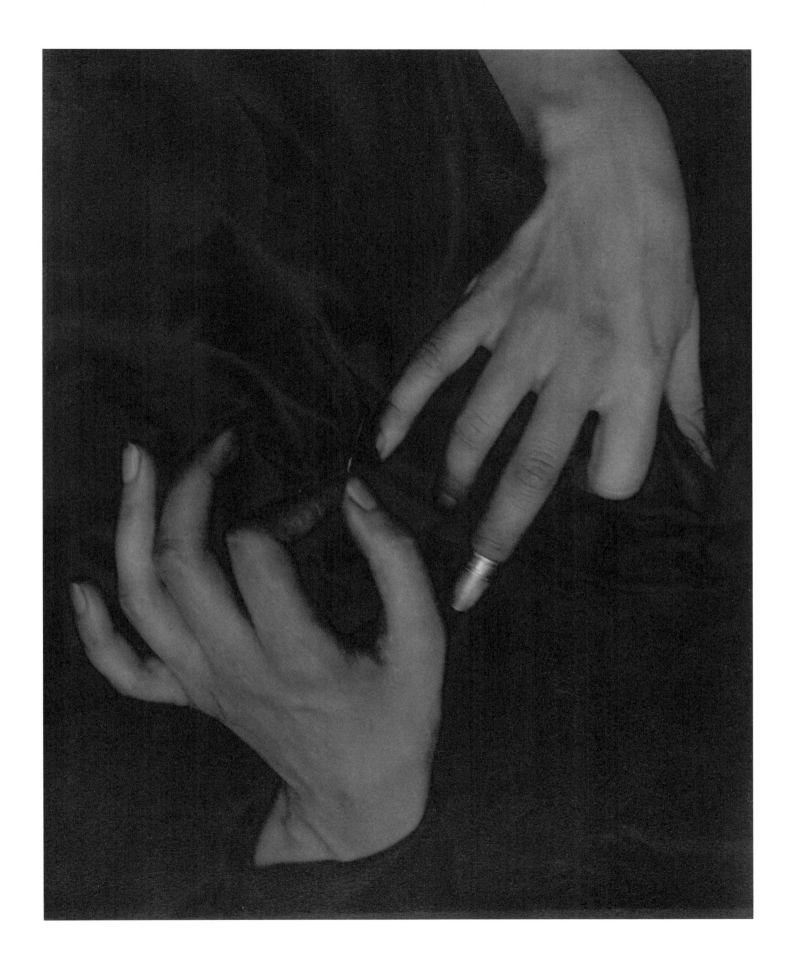

21. Georgia O'Keeffe: A Portrait (9). 1920

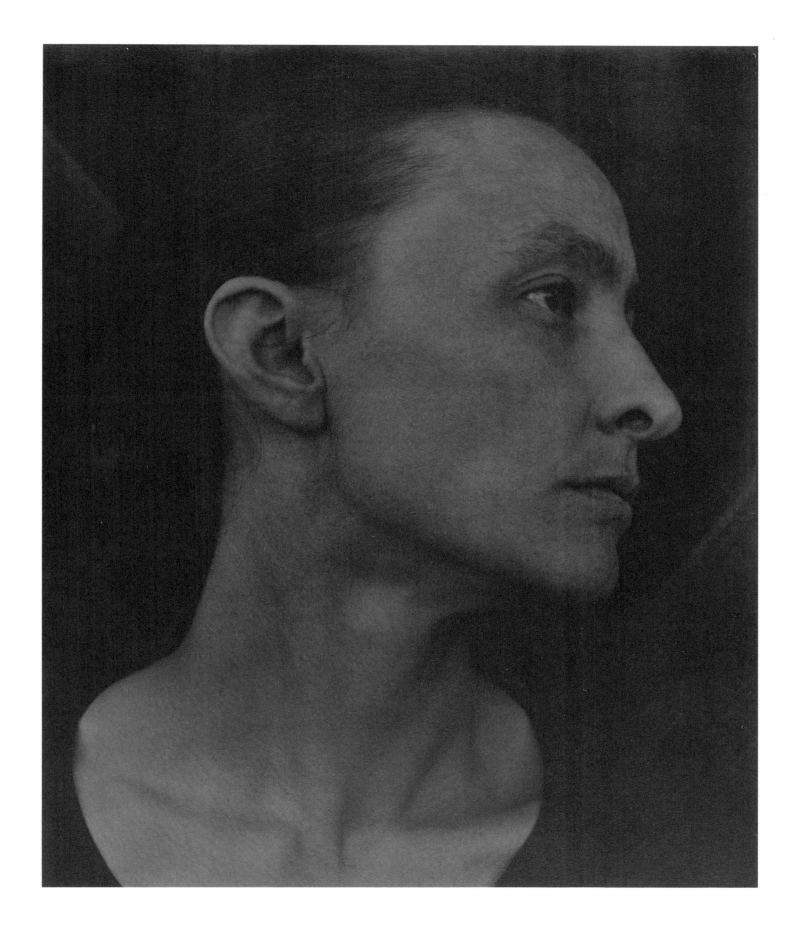

23. *Georgia O'Keeffe: A Portrait (11). 1921(?)*

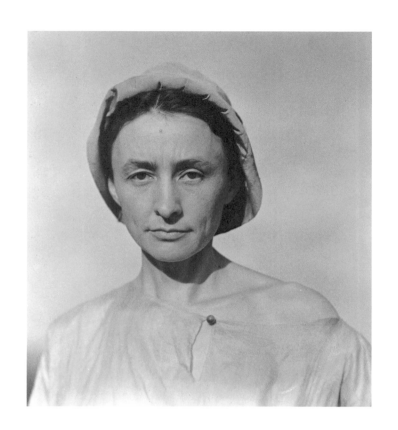

24. Georgia O'Keeffe: A Portrait (12). 1922

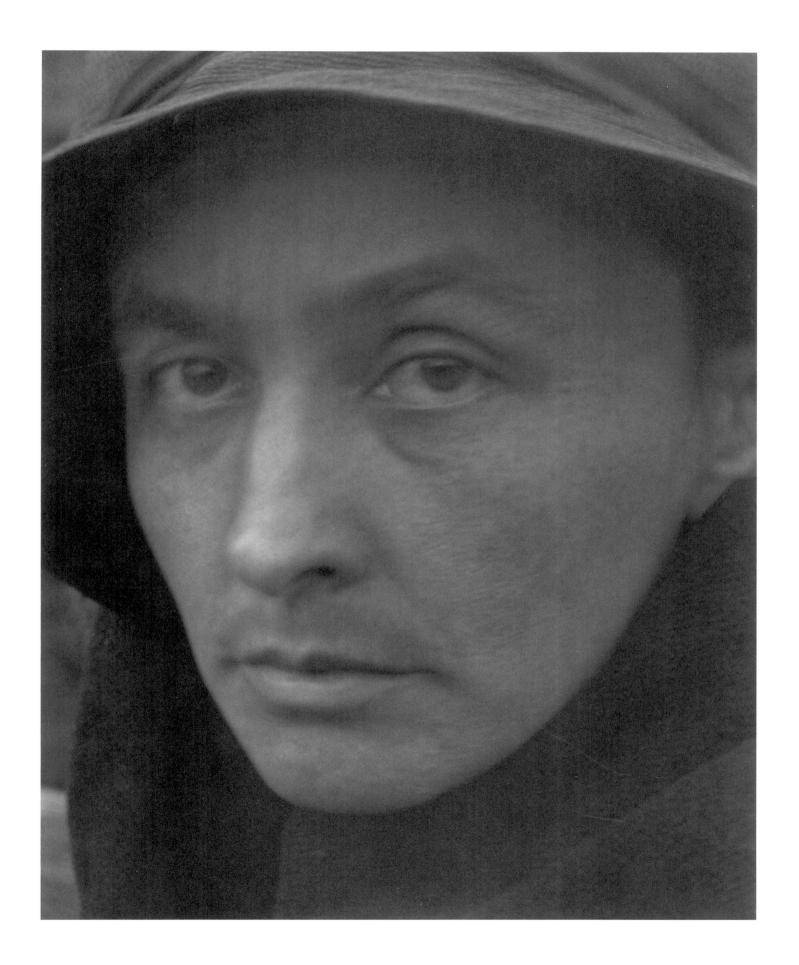

25. Georgia O'Keeffe: A Portrait (13). 1922

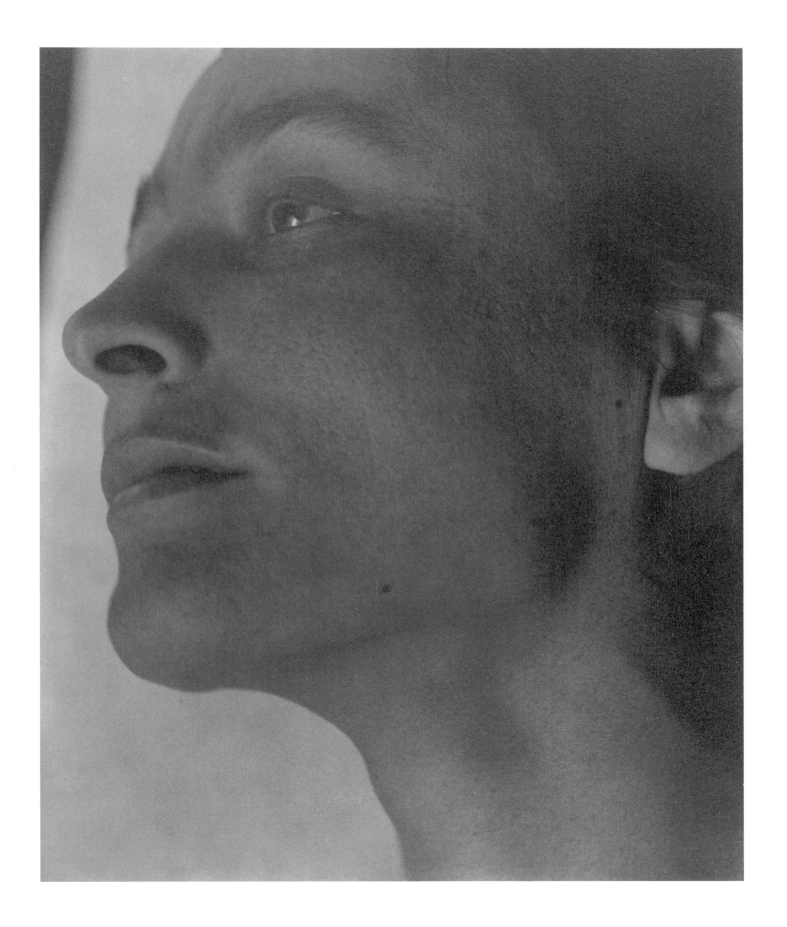

26. *Georgia O'Keeffe: A Portrait (14). 1923*

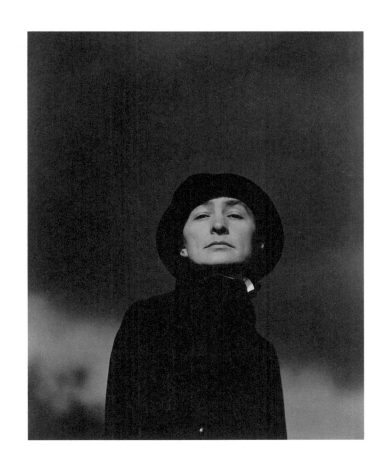

27. *Georgia O'Keeffe: A Portrait (15)*. *1930*

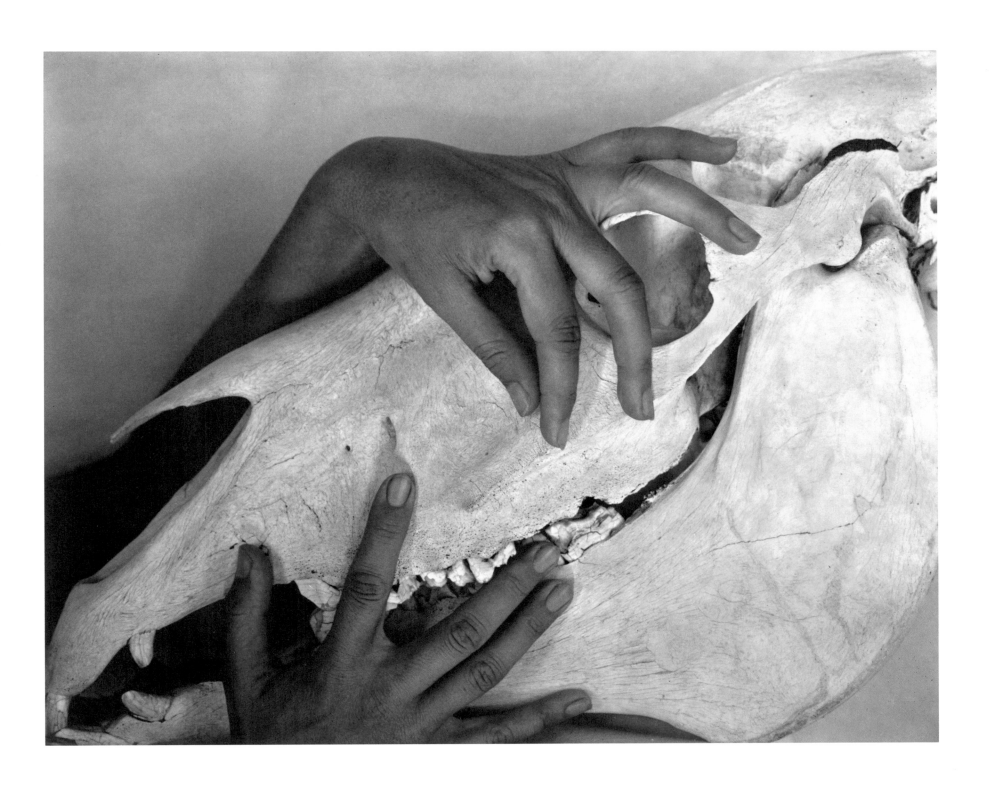

28. Charles Duncan. 1919

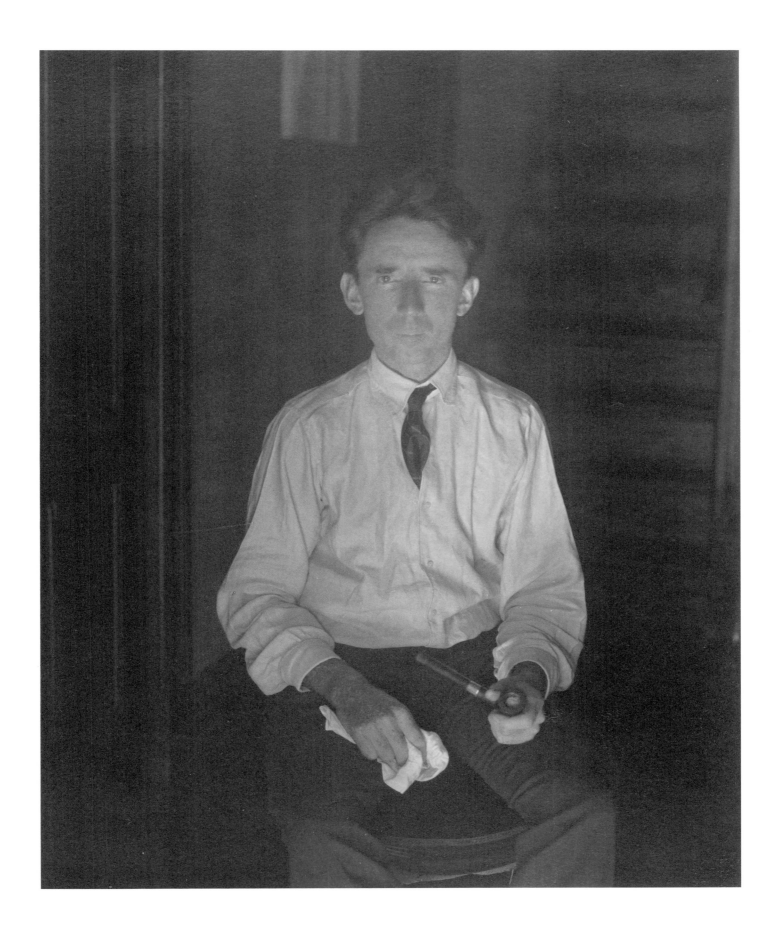

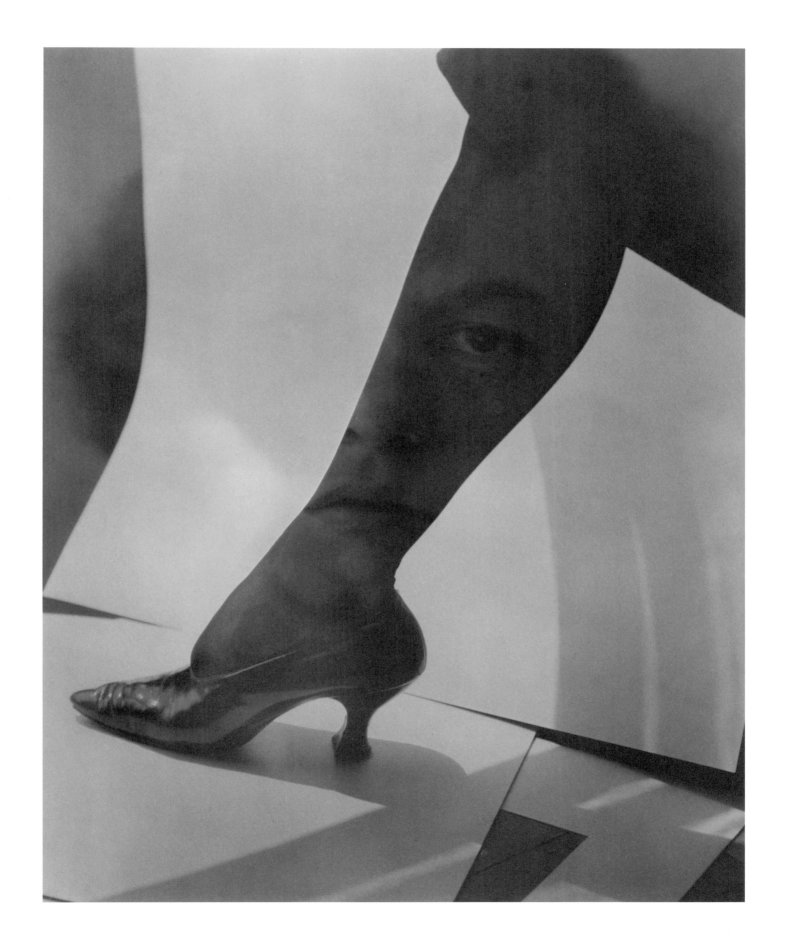

30. Georgia Engelhard. 1921

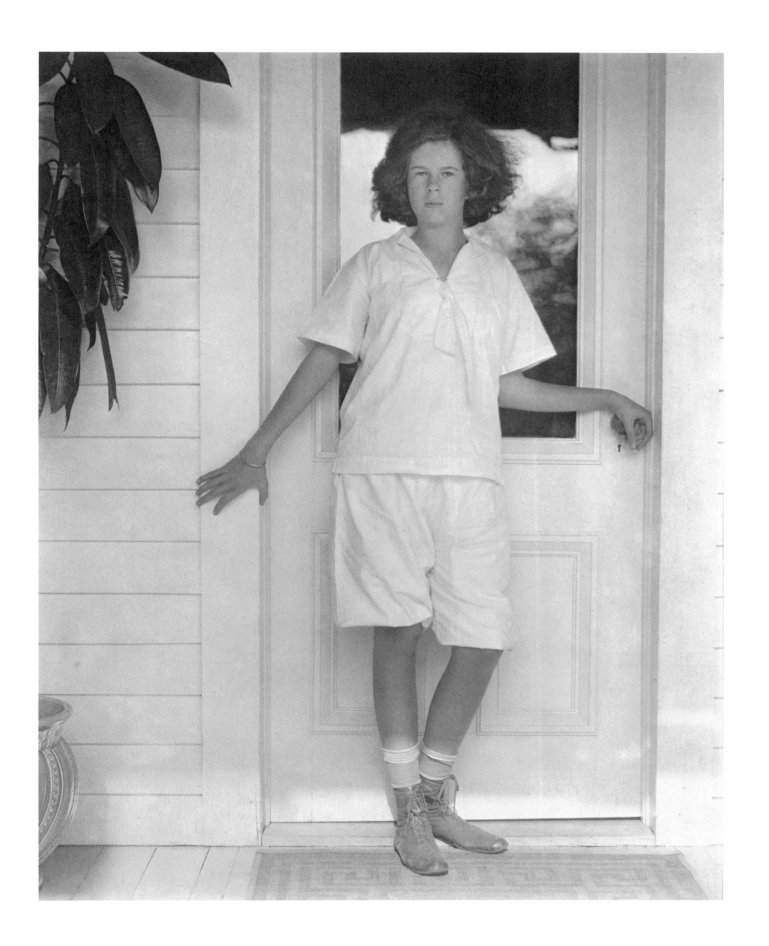

31. Helen Freeman. 1921

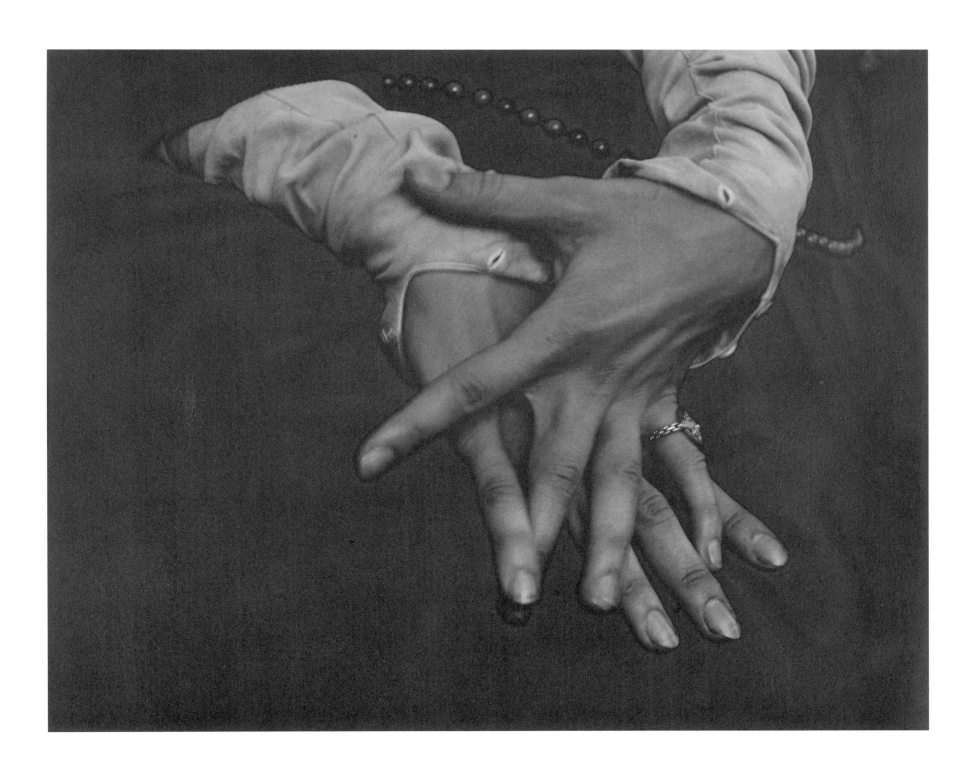

32. Margaret Treadwell. 1921

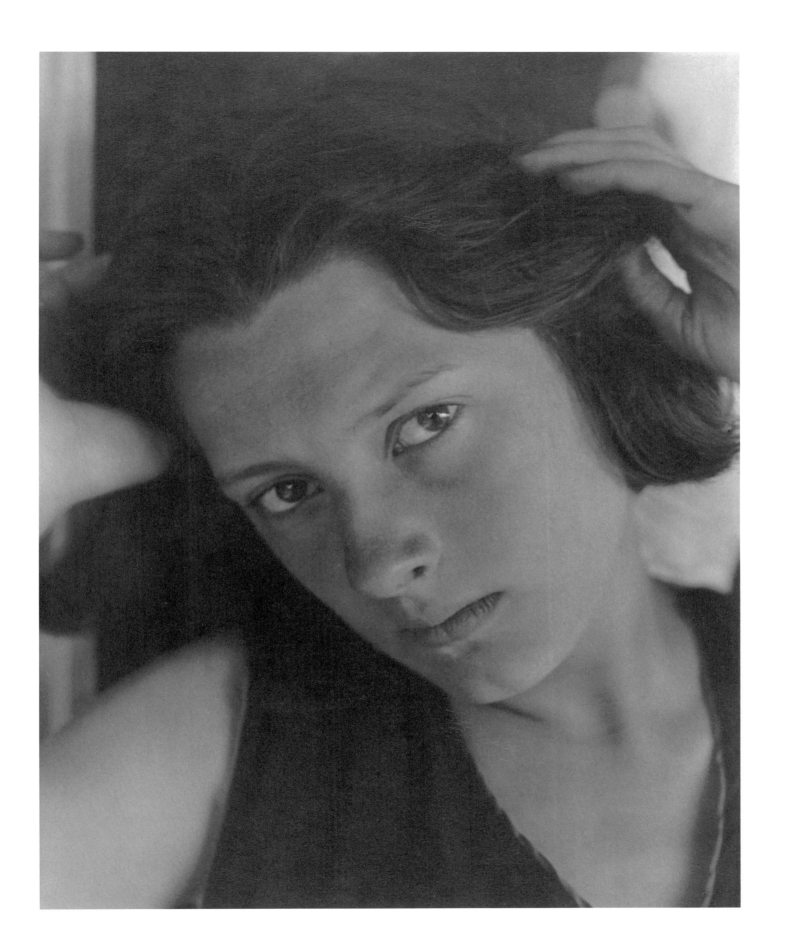

33. *Apple and Drops of Rain, Lake George.* *1921(?)*

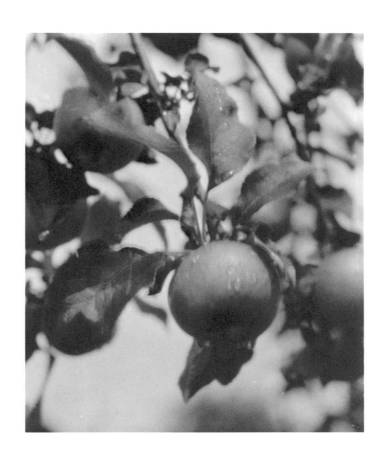

34. Dancing Trees. 1921

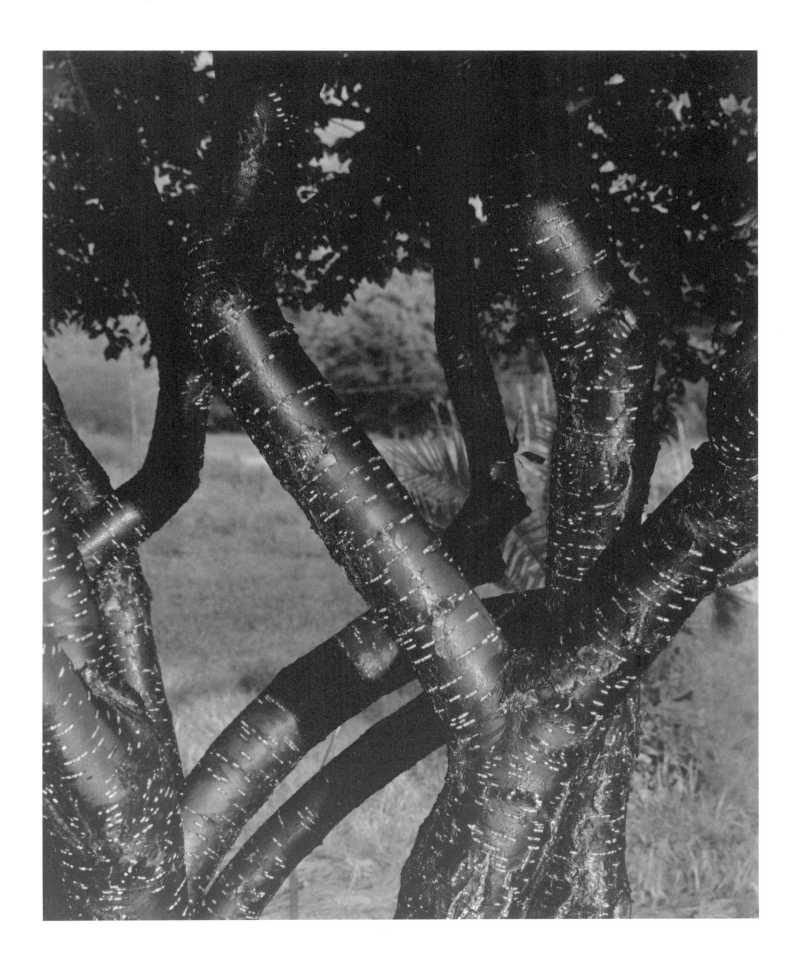

35. John Marin. 1922

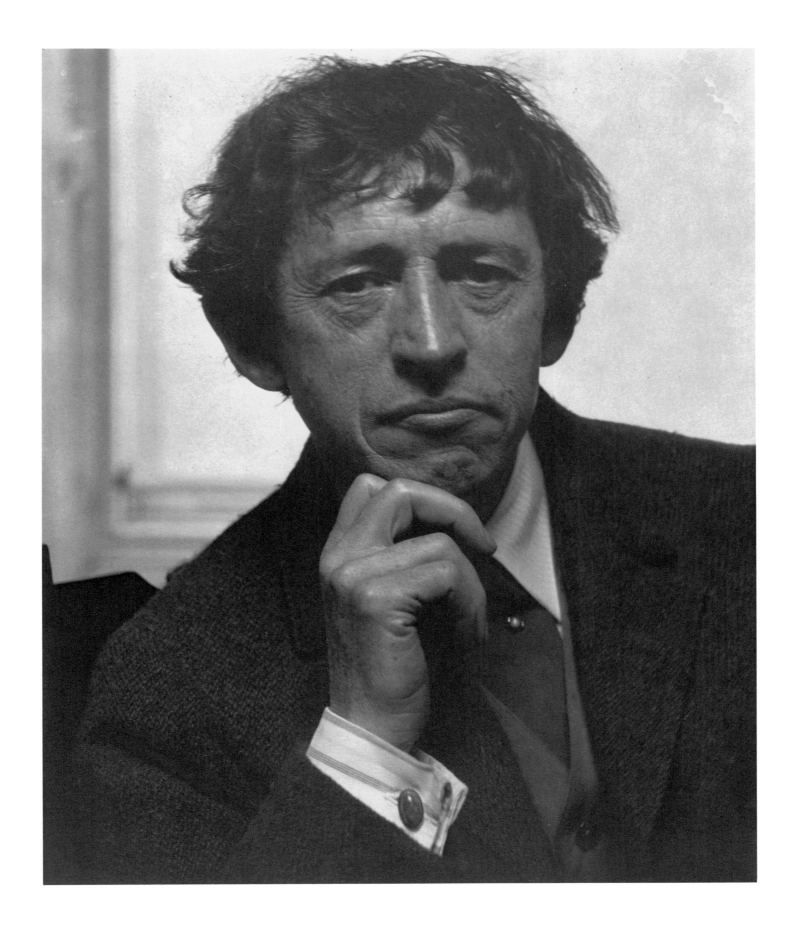

36. Portrait of A.W. 1922

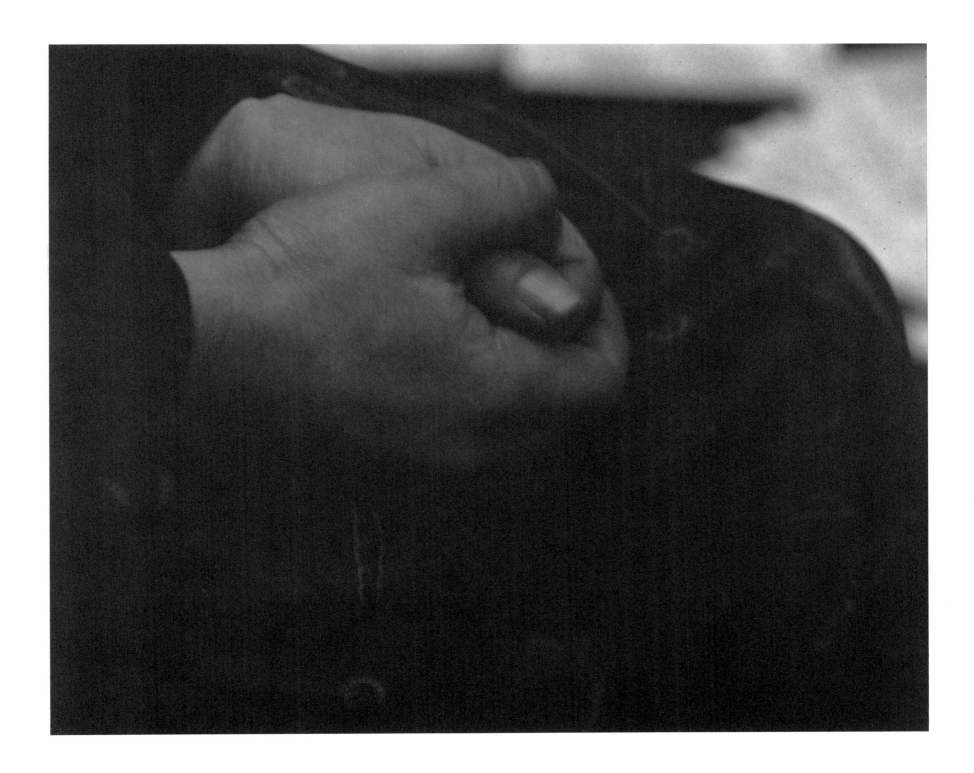

37. Chicken House, Lake George. 1922

/

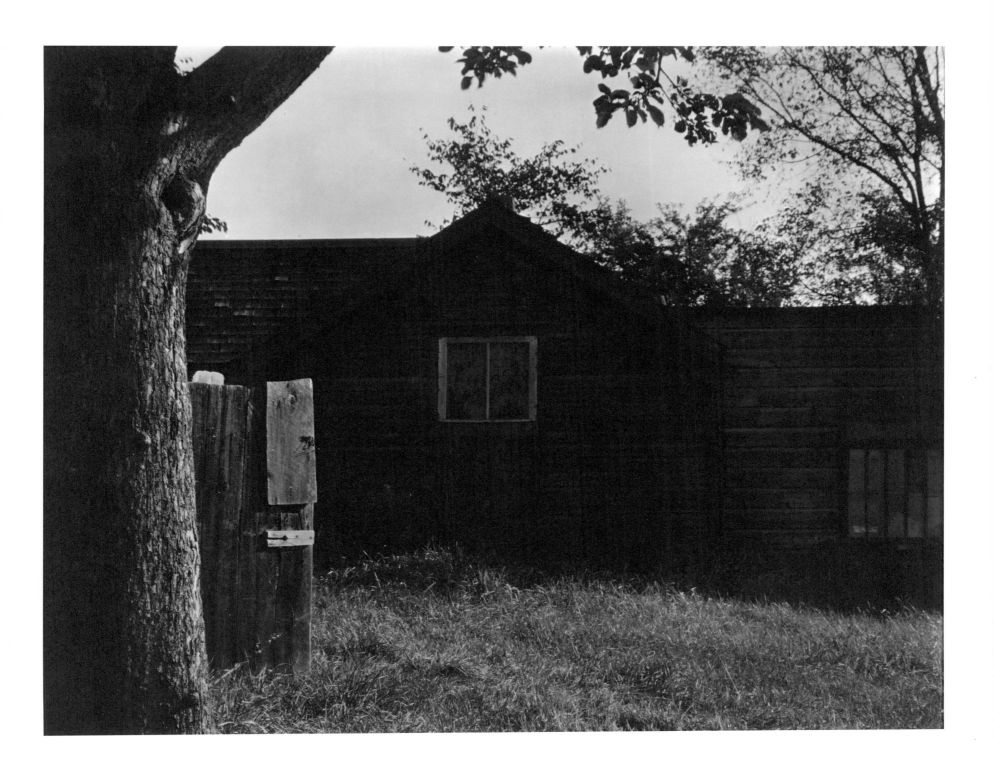

38. Music. 1922

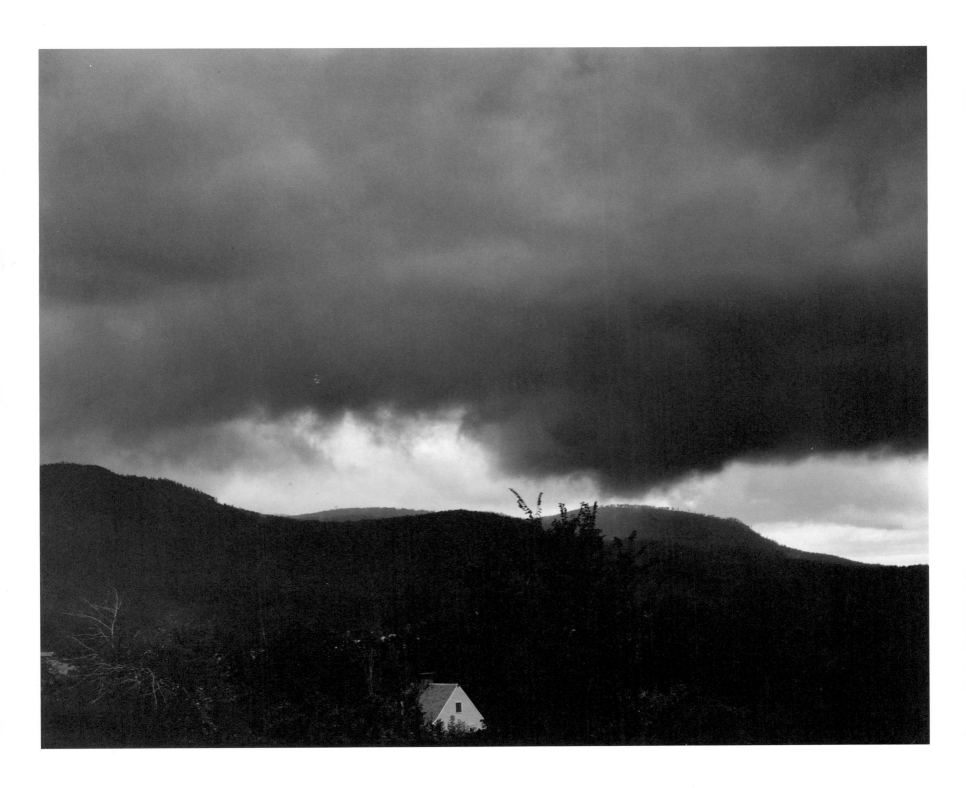

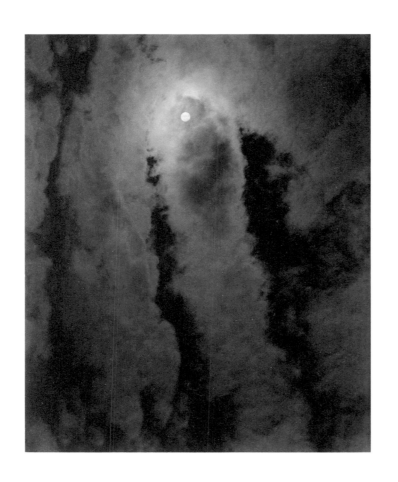
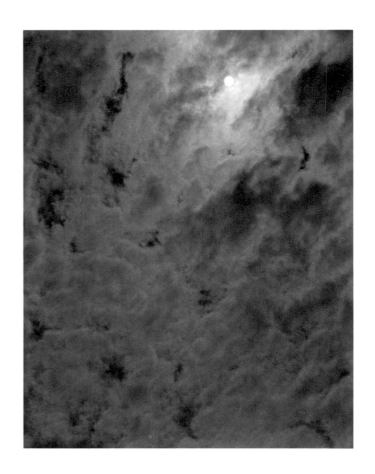

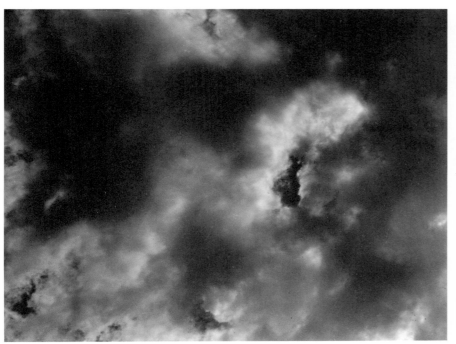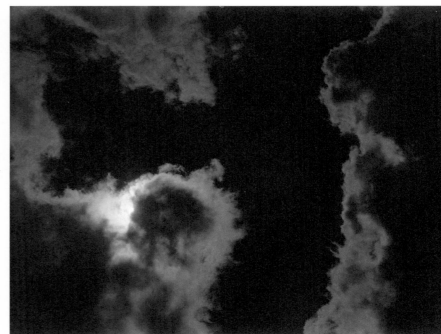

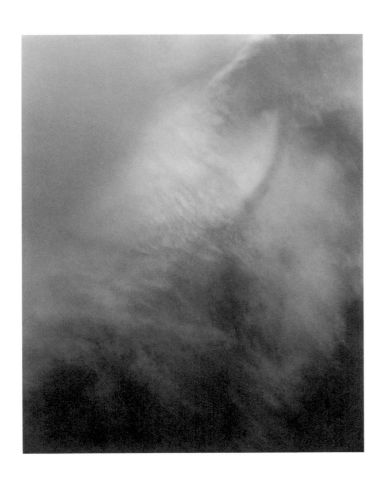

44. *Spiritual America.* 1923

45. Chicken House Window with Snow, Lake George. 1923

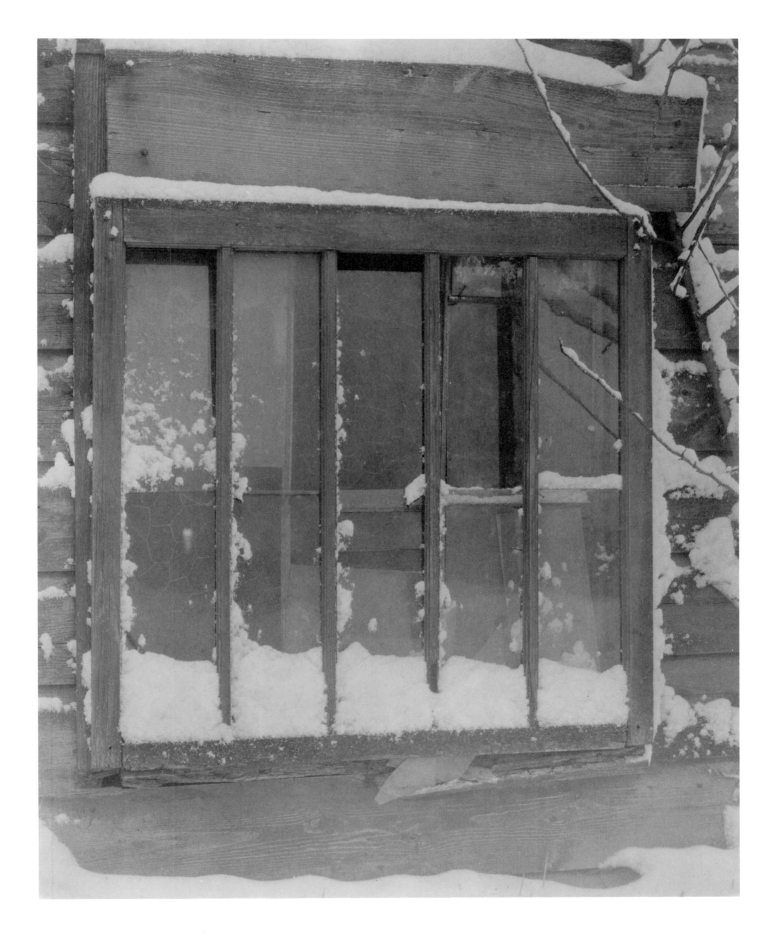

46. Portrait of R. *1923(?)*

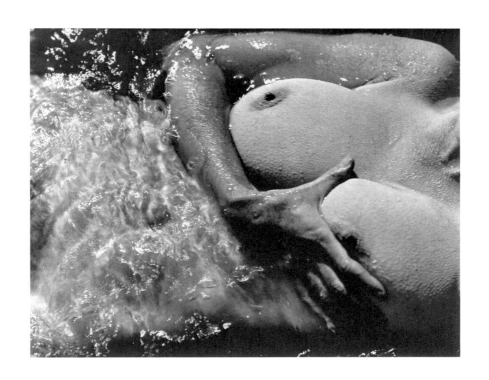

47. Side of Barn, Lake George. 1923(?)

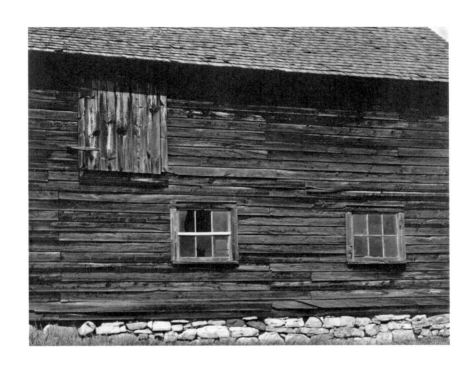

48. Equivalent. 1926(?)

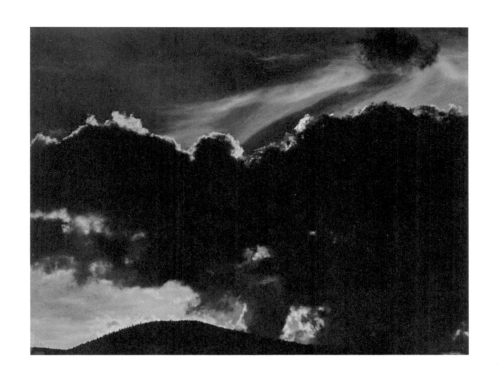

49. *Chestnut Trees, Lake George. 1927*

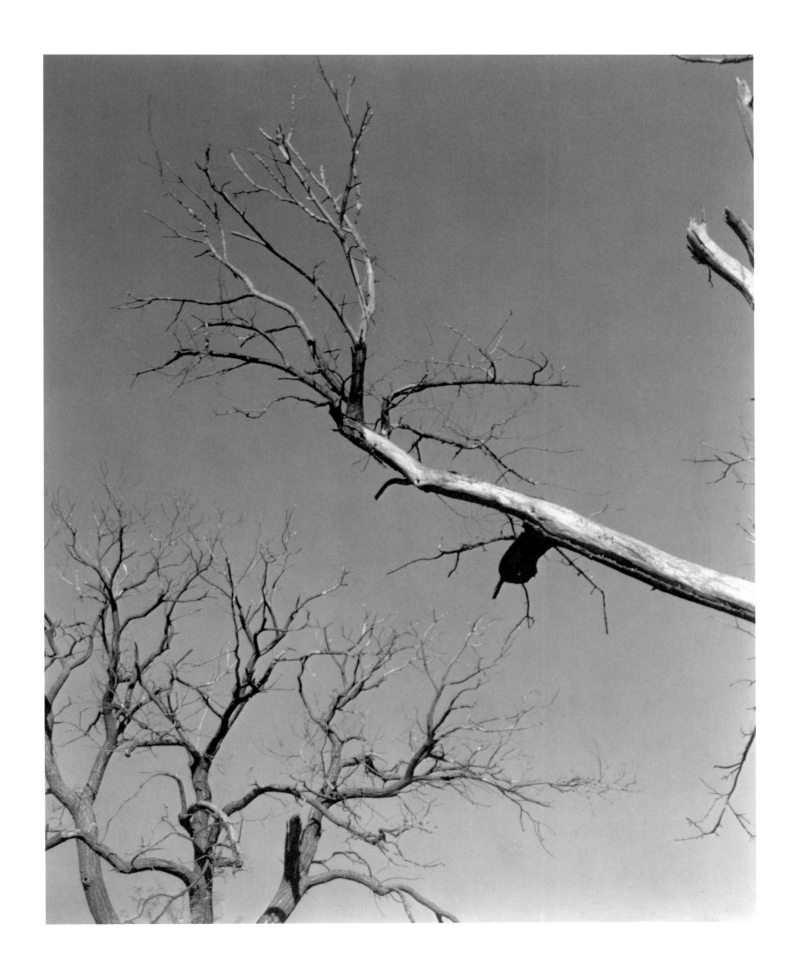

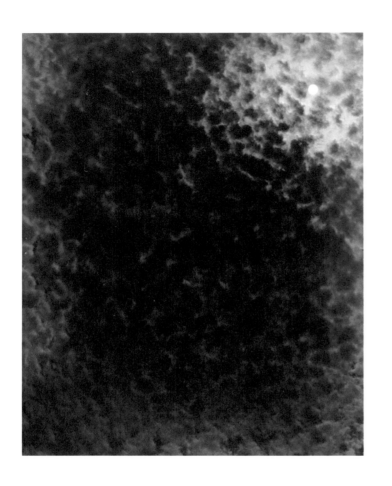 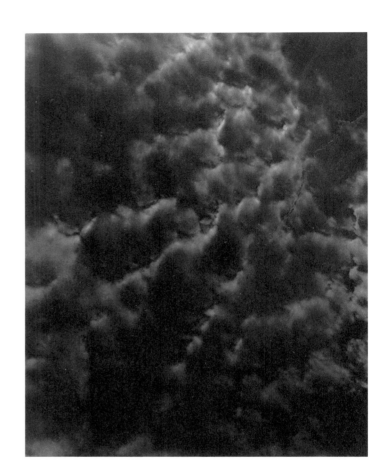

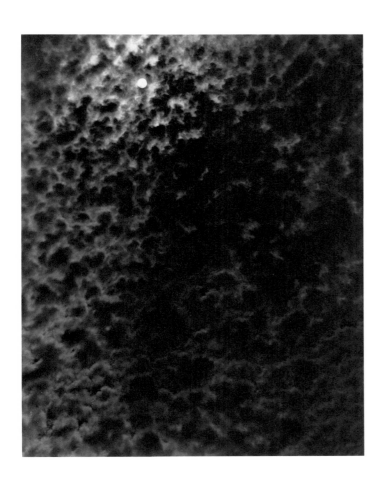

50. *Equivalent, Set G (No. 1). 1929*

51. *Equivalent, Set G (No. 2). 1929*

52. *Equivalent, Set G (No. 3). 1929*

53. Equivalent. 1929(?)

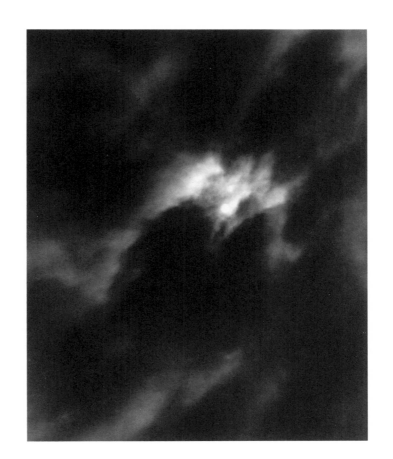

54. Equivalent. 1930

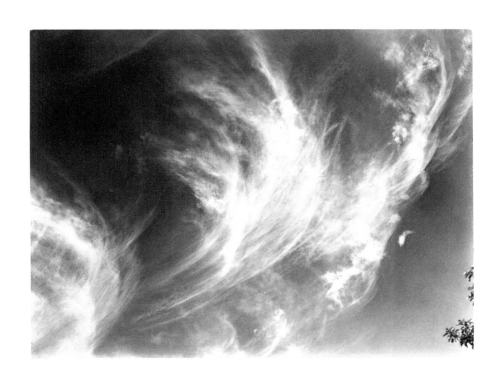

55. From An American Place, Looking North. 1931

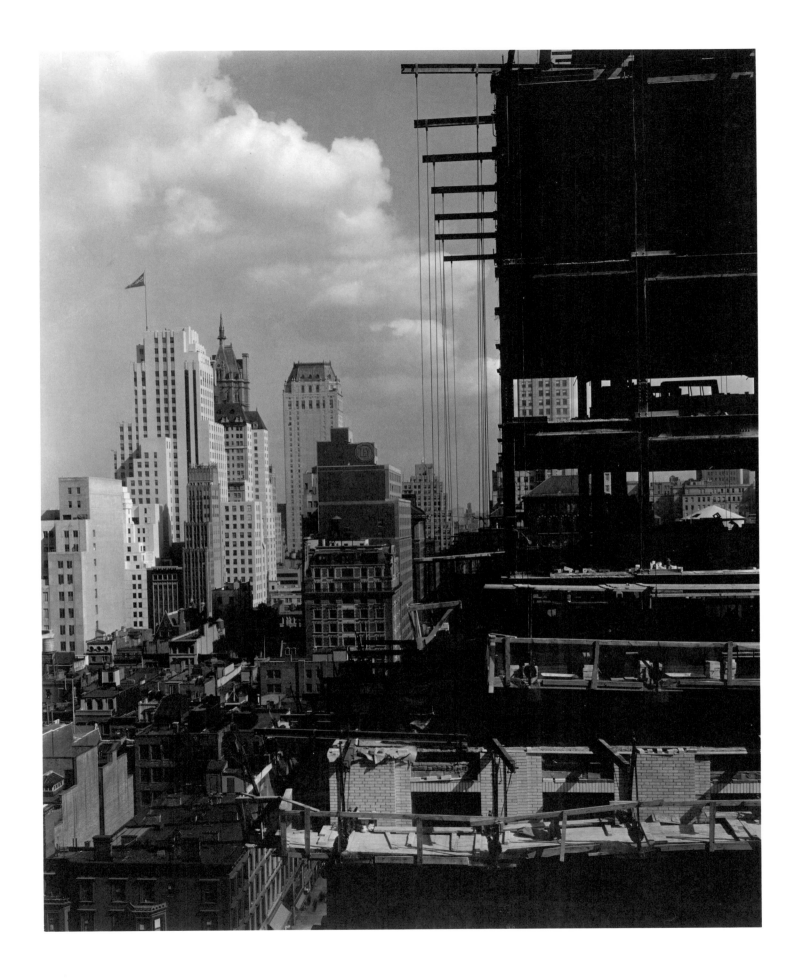

56. Poplar Trees, Lake George. 1932(?)

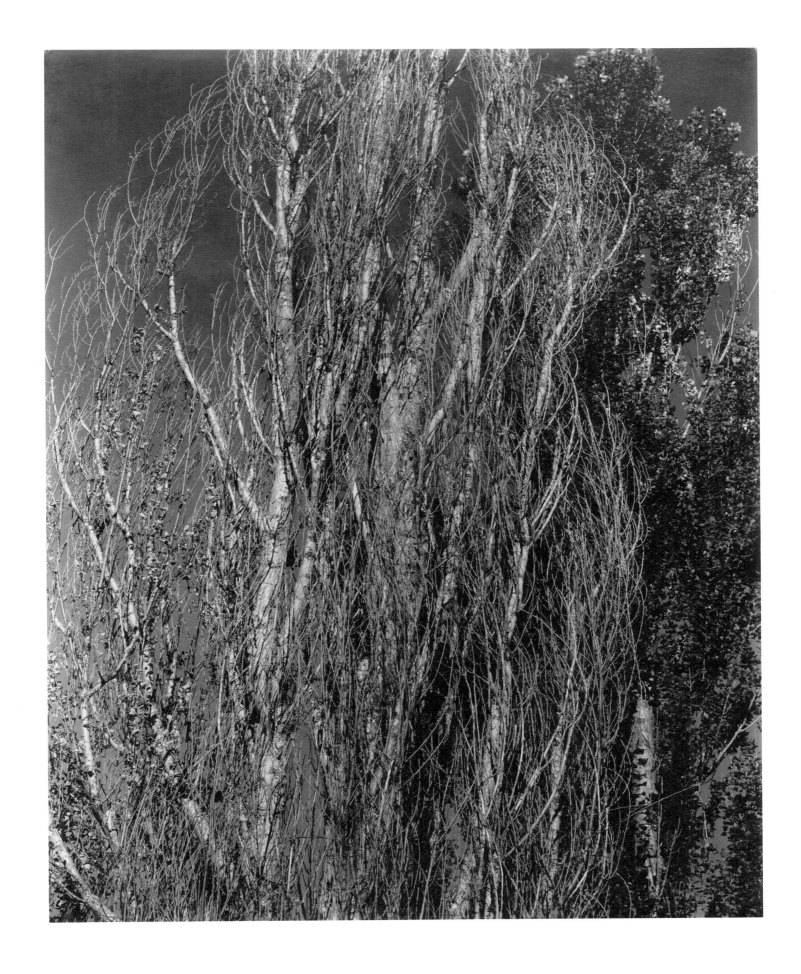

57. Cary Ross. 1932

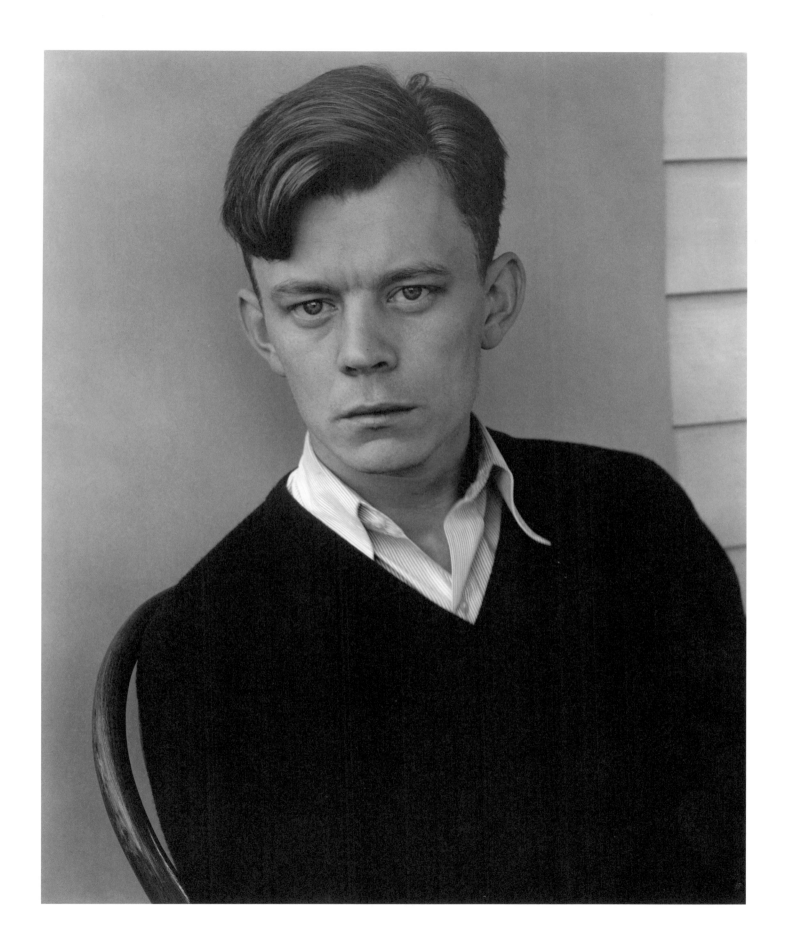

58. From the Shelton, Looking Northwest. 1932(?)

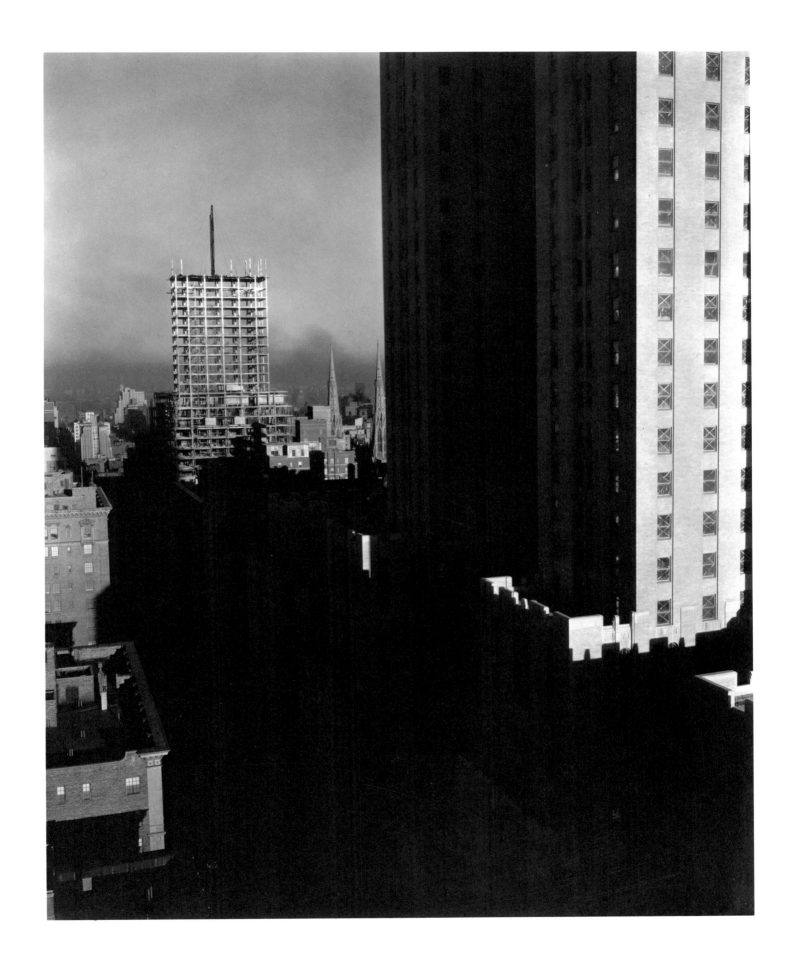

59. *Lilac Bushes with Grass, Lake George.* 1933

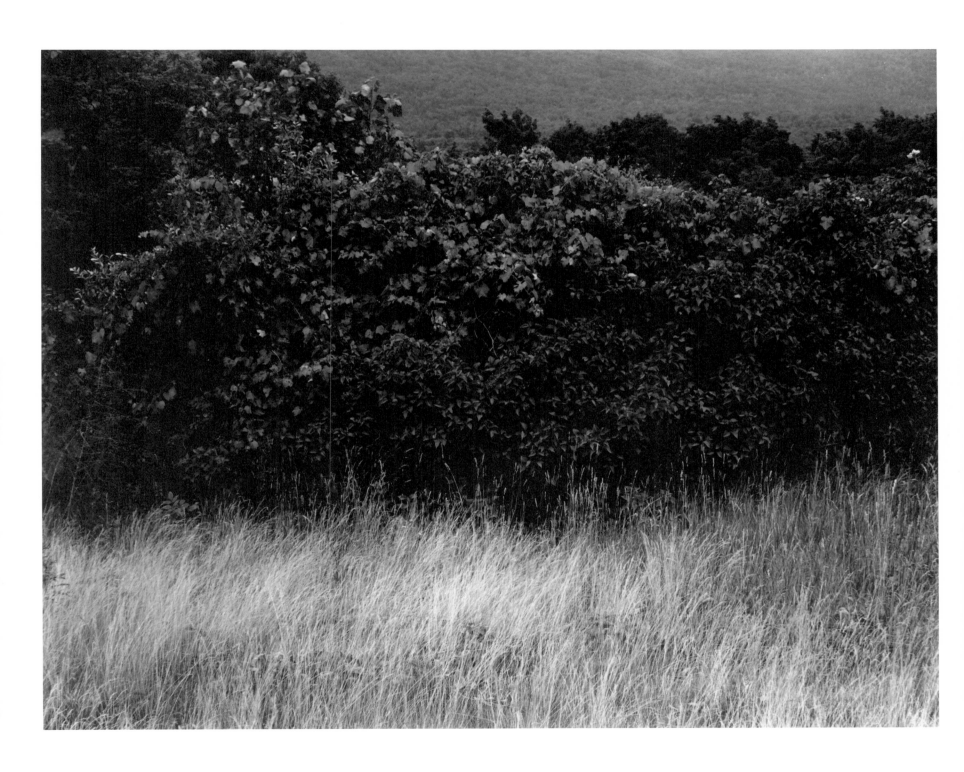

60. From the Shelton, Looking West. 1933(?)

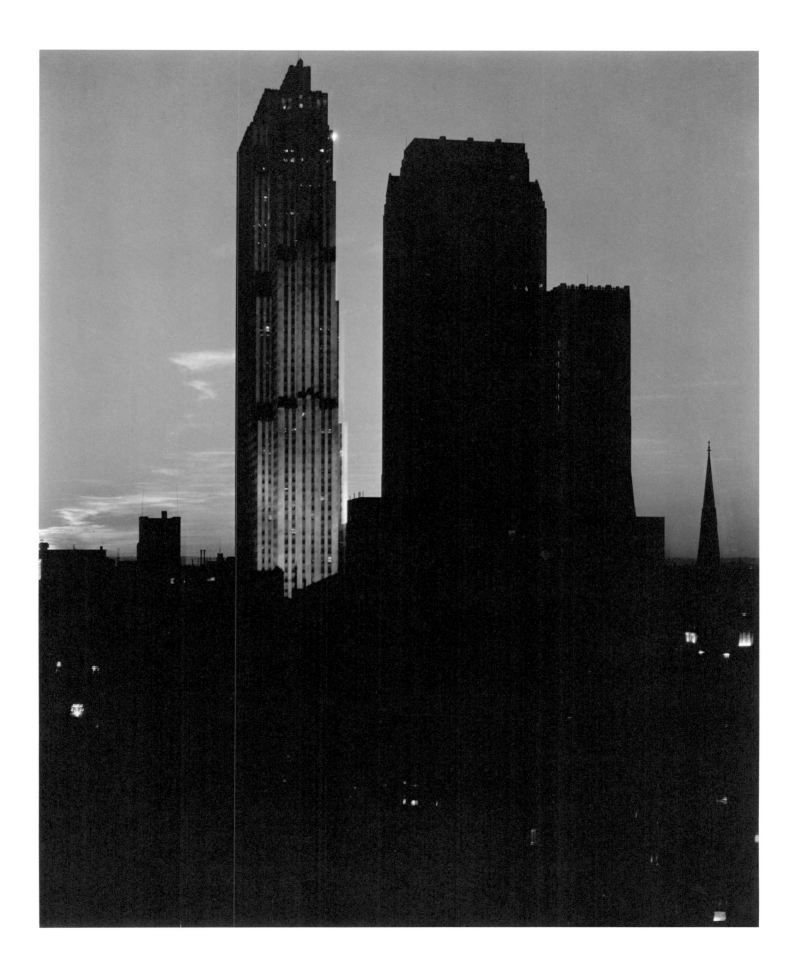

61. Porch with Grapevine, Lake George. 1934

62. Poplars, Lake George. (?)